What is packaging design?

We only see what we look at.
To look is an act of choice.
John Berger

RotoVision

A RotoVision Book
Published and distributed by RotoVision SA
Route Suisse 9
CH–1295 Mies
Switzerland

RotoVision SA
Sales & Editorial Office
Sheridan House
114 Western Road
Hove BN3 1DD UK

Tel : +44(0)1273 72 72 68
Fax: +44 (0)1273 72 72 69
E-mail: sales@rotovision.com
Web: www.rotovision.com

1 0 9 8 7 6 5 4 3 2
ISBN: 978-2-940361-88-5

Editor: Leonie Taylor
Design: Lippa Pearce

Reprographics in Singapore by
ProVision Pte. Ltd.
Tel: +65 6334 7720
Fax: +65 6334 7721

Printed in China by Midas Printing International Ltd.

Nature's answer
The chicken came first with
the ultimate in effective
packaging design.

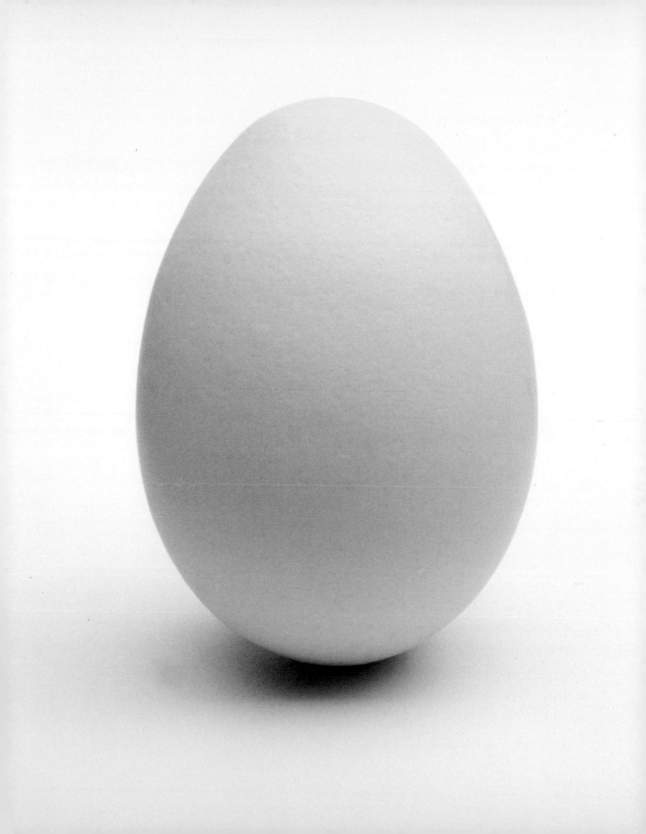

Issues

Anatomy

Portfolios

Etcetera

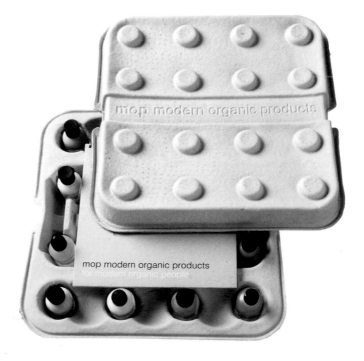

Eggs as inspiration
The use of an "egg box" to carry the products is both an interesting use of materials and in keeping with the brand's "organic" roots. Designed by Liska and Associates.

The role of packaging

Packaging emerged in the 19th century as new technologies enabled manufacturers and growers to supply their products to stores in pre-packaged formats. For the first time, these technologies enabled produce growers to harvest their products, can them while fresh, and transport them to market. It also meant product manufacturers could package products in an attractive way for merchants to sell.

Packaging's utilitarian functions

In the early days, packaging's role was essentially utilitarian. It aided the efficient distribution of merchandise and presented products in an attractive manner. To this day, these basic functions play a major part in the form and function of packaging. Products may have become more sophisticated but there is still a basic requirement to protect them. Distribution may have become a complex process, but products still need to survive transportation so that they arrive pristine on-shelf. Product display is as important today as it was in 1895, when Jack Daniel launched his new square shaped whiskey bottle.

Packaging's place in the marketing mix

As Robert Opie points out in *Packaging Source Book* (1991): "The basic functions of the sealed package—to protect the product, to enhance its appearance and to facilitate its distribution— were soon to be matched by others, more subtle perhaps, but no less far-reaching in their consequences." He goes on to describe the effect the appearance of a "manufacturer's package" (with its implicit definition of quality and quantity) had on retailing. Ultimately it led to the disappearance of the provision merchant and the appearance of the self-service retailer.

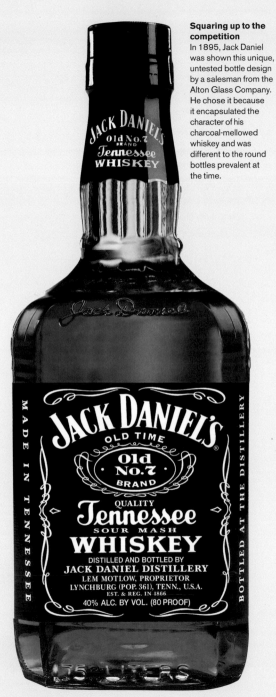

Squaring up to the competition
In 1895, Jack Daniel was shown this unique, untested bottle design by a salesman from the Alton Glass Company. He chose it because it encapsulated the character of his charcoal-mellowed whiskey and was different to the round bottles prevalent at the time.

Opie could just as easily be referring to packaging's other new roles that have developed over recent years as marketing has become more sophisticated. One of the most prominent of these new roles relates to packaging's place in the marketing mix. Marketeers now have a broad range of media to exploit. Packaging must be added to this canon. As Paul Southgate notes in *Total Branding by Design* (1996), it was James Pilditch who first recognized the importance of packaging as a marketing tool in *The Silent Salesman* (1973).

Sales tool and brand manifestation

Although packaging's importance still seems to depend upon a particular marketing discipline's own self-interest, it is now recognized that it is no longer a passive, functional device but an active sales tool that can make its presence felt in a crowd, and sell a product at the point of purchase. Moreover, with the prominence of branding, packaging is often the living embodiment of a brand's values and personality. Time and effort is spent defining these attributes and traits, understanding consumers' perceptions of them, and then manipulating packaging design to communicate them. Packaging design plays a pivotal role in ensuring consumers' perception of the brand is mirrored on the pack. Consumers make a brand purchase just as much as they make a product purchase. They may in reality be buying a face cream but their choice is affected by their perception of the brand and its inherent promise.

Product differentiation

Packaging has always played its part in distinguishing one manufacturer's product from another. Its first manifestations—labels—were crafted to do just that. Now the whole differentiation process has become increasingly sophisticated. Whereas graphics once took the lead role in distinguishing one product from another, structural packaging now plays a major role in brand differentiation. Sometimes this is achieved with shape—the classic Coke bottle being the obvious example—but at other times it's achieved with color, finish, or materials. Perrier bottles are such a distinctive green that the manufacturers effectively "own" the color green in the bottled water sector. In some sectors, like cosmetics and fragrances, the tactile feel of a particular piece of packaging communicates lifestyle aspirations on a subliminal level.

Lifestyle and behavioral patterns

Packaging's role has also extended in response to consumers' changing lifestyles. For example, people now live more mobile lives and packaging has developed to accommodate this.

In simplistic terms, this has led to the development of travel-size variants of products but it has also led to packaging designed specifically to fit in handbags, briefcases, and other luggage. People also pursue a vast array of interests and, in areas like sport, demand products that not only support their performance but perform in a way that relates to the activity undertaken. Lucozade sports drinks, packaged in metal pouches with drinking nozzles, are a good illustration of this: easy to carry and use, the pack is perfect for sportspeople. As Southgate says: "The whole pack encapsulates relevant brand values (energizing, dynamic, youthful). The whole pack is the brand identity."

Beyond the functional

For many years certain types of packaging have had a role beyond the purely functional. Packaging has become something to value in its own right, something to be displayed because it has a certain cachet. The most obvious example of this is perfume packaging where the display of a leading name is *de rigueur*. In recent years packaging "display" has become part of certain types of design brief as a response to the sheer power of brands and the concomitant status they convey on the owner. Packaging acquires an importance disproportionate to the product itself. Even in sectors like men's toiletries it is important to understand the role brands play as status badges. Young men, for example, need to feel comfortable using their deodorants in public

spaces, such as changing rooms—as the packaging is the brand, it plays a huge role in positioning the brand correctly.

Packaging's display value has also increased as a result of consumers' pride in their homes. In sectors like bath products, they want attractively packaged goods which they can feature next to decorative items on their shelves. It's no longer enough that a product is effectively packaged in a bottle with a label that communicates its benefits and fragrance—it now has to be aesthetically pleasing enough to satisfy consumer tastes, in turn influenced by magazines, TV programs, and "design gurus".

In short, packaging performs a number of diverse roles: from the purely functional to brand championship, from effecting efficient distribution to product and brand differentiation. The sheer diversity of these roles acts as both the determinant of a design solution and as a catalyst to the development of new ideas.

Brand associations
Consumers buying Philip B haircare products in stores like Nieman Marcus, Bergdorf Goodman, and Barneys are not only buying a haircare product but the associated kudos of Philip B. himself, the "international haircare guru", hairdresser to the stars, and regular feature in magazines like *Vogue* and *Elle*. Designed by Adams Morioka.

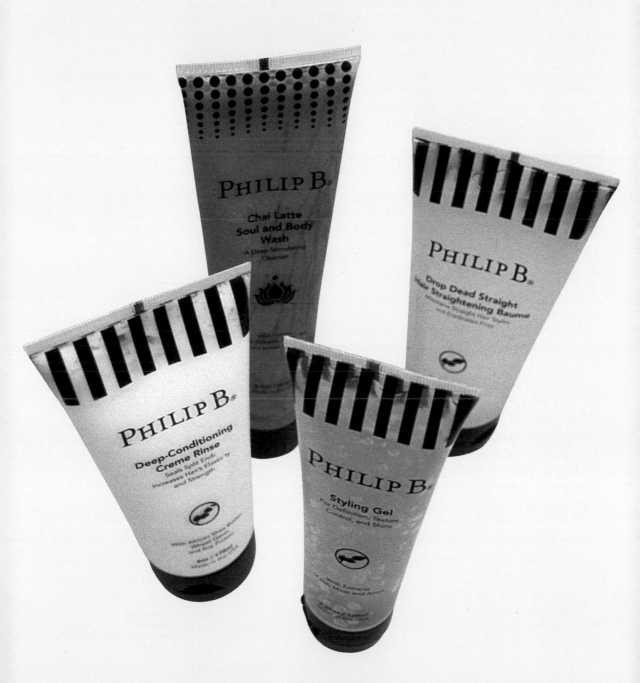

An historical perspective

Packaging's development has been affected over the centuries by advances in technology, by transportation developments, and by societal changes. Just as progress and change have had an impact on all aspects of our lives, so have these things influenced packaging. Technologies created to transport food into space now appear in our stores. Increasingly sophisticated print technologies mean that things that were unachievable ten years ago, such as half-tone printing onto certain plastic substrates, are now commonplace.

The old and the new

Opie's *Packaging Source Book* illustrates how packaging, and its design, has developed over the years. Having visited his now closed packaging museum in Gloucester, UK, I was struck by the way the exhibition's historical progression from the early 1800s to the present day accentuated the consistency of some packaging formats, and highlighted the appearance, every decade, of new formats and ways of dispensing products.

What is interesting about this phenomenon is that the introduction of new packaging formats and designs is driven by manufacturers creating new products; by packaging technologists and producers devising new solutions to their clients' needs; by brand managers driven by market imperatives such as brand profile and differentiation; and by designers seeking to answer their clients' briefs by employing, to use creative thinking guru Edward do Bono's words, "lateral" and "vertical" thinking. Each "driver" is spurred by a different desire. For example Tetrapak's carton technology originated from the desire to create a milk package that required minimum material and maximum hygiene.

The influence of the times

Any review of packaging design also reveals the influence of artistic, cultural, and lifestyle factors. Jerry Jankowski's *Shelf Space: Modern Package Design, 1945–1965* (1998) graphically illustrates the influence of things like art, films, and fashion on packaging design. Looking at the designs created for the fragrance *Shocking* by Elsa Schiaparelli, or *Le Roi Soleil* by Salvado Dali, one can see the spirit of the heady 1950s reflected.

Designers are like sponges soaking up different influences, either consciously or unconsciously, and these manifest themselves in their design solutions. Good designers know how to manipulate these influences to transcend mere fashion, cosmetic solutions, to create designs that reflect the zeitgeist and are relevant and meaningful to consumers.

Progress and change
In 1897 Shiseido introduced its first cosmetic product, Eudermine (right). Taking its name from the Greek for "good skin" Eudermine skin lotion embodied the latest pharmaceutical technology of the day and the company's desire to create "cosmetics that nature beautiful, healthy skin." The product's packaging is very much of the period. By 1997 Eudermine's packaging had changed radically (far right), the new design reflecting the tastes and design influences of the late 20th century.

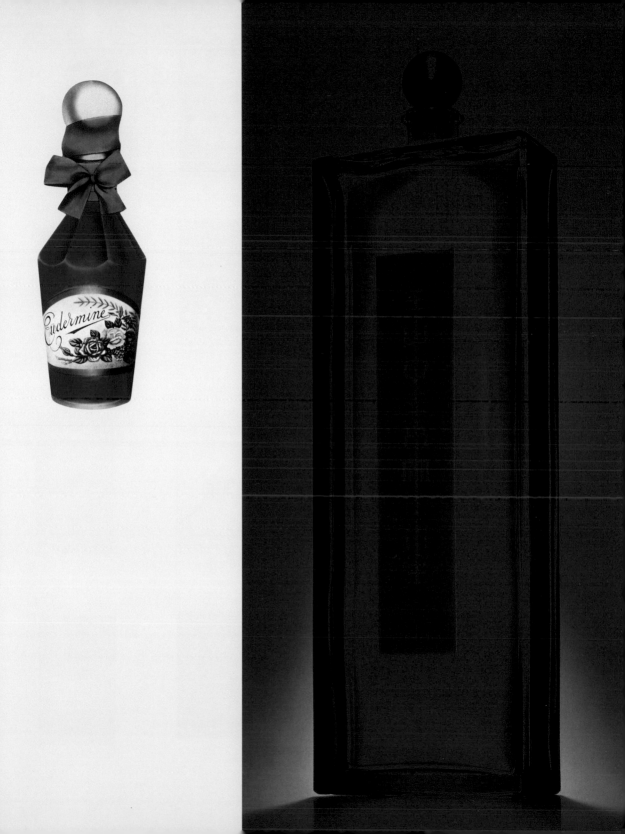

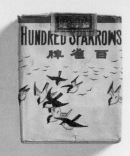

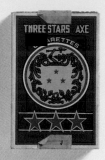

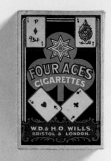

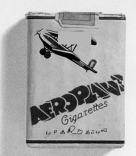

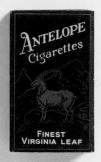

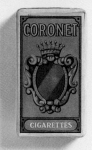

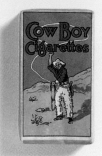

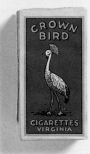

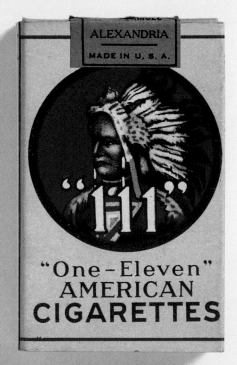

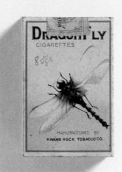

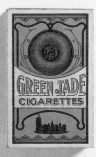

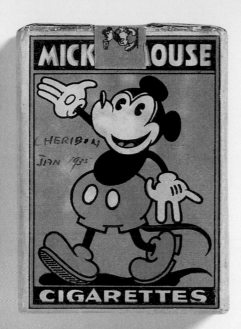

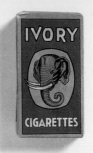

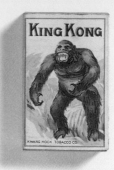

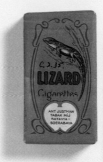

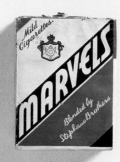

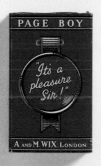

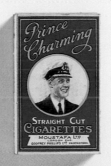

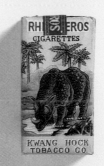

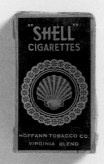

Smokers' history
These cigarette packets are
almost an historical snapshot
of a bygone era. The names,
typography, and imagery
speak of a time in the 1930s
when cultural, political, and
social influences were quite
different from the present.

Marketing considerations

Although media mogul Rupert Murdoch is famous for banning the use of the word "marketing" from his newspapers, for most brand and product owners, it is an essential element in the promotion of their products, and the encouragement of consumer awareness and purchase. Marketing is a compound of a large number of elements, each exploited in different ways depending on the type of product, its age, its marketplace, price point, and target market.

Packaging design is just one of the elements in the marketing process. Championed (obviously) by those who practice it, it is valued to differing degrees by those who "own" marketing: marketing directors and managers, brand owners and managers. If my clients are anything to go by, packaging design is either considered a vital part of the whole marketing program or something that is allocated a minuscule budget in comparison to advertising or sales promotion.

The *Anatomy* section (page 68) explores why packaging design should be considered an invaluable and powerful component of the marketing mix—above all because it is commercially effective when practiced properly— and looks at an issue, globalization, which is such a factor in many brand owners' lives.

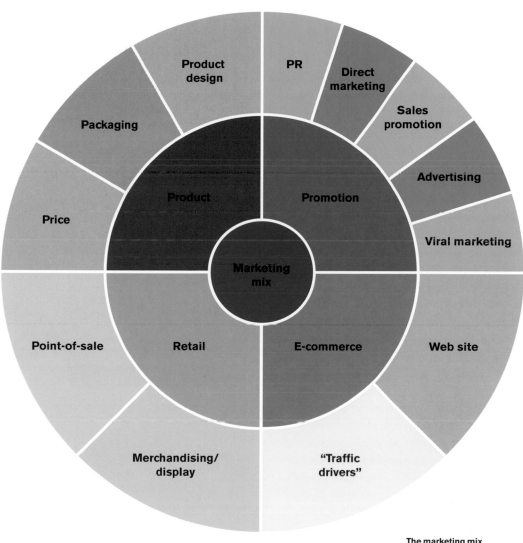

The marketing mix
Packaging's part in the product marketing mix

Packaging in the marketing mix

Simplistically, the marketing mix is a short-hand expression, beloved by marketeers, that describes all of the different media available to promote a product. It encompasses advertising, sales promotion, point of sale, public relations, direct marketing (such as direct mail and off-the-page advertising), and design.

Latterly, it has also come to include new media types like on-line advertising and viral marketing. Flyposters appear overnight, often with a 'teaser' message, papering walls and street furniture and incurring the wrath of municipal councils and the displeasure of public utility owners. Moreover, changes in national advertising legislation is forcing certain companies, such as cigarette manufacturers, to refocus their spend on media such as direct marketing to reach their target audience.

In an ideal world, a product marketeer has generous budgets and can devise a marketing strategy and media plan that exploits each of the different media to their full potential. Advertising and public relations campaigns are executed to generate consumer awareness; sales promotion strategies to encourage new product trial or counter aggressive competitor pricing; point-of-sale activity to alert consumers to the presence of a product in-store and communicate product or offer stories in detail; and packaging design to sell the product at the point of purchase.

The world is seldom ideal and budgets are more often tight than generous, leading marketeers to cut their cloth accordingly. Every spend is scrutinized to ensure the selected media achieve their goal. Packaging design comes under the spotlight for several reasons: is the design working hard enough to achieve maximum "shout" at point of purchase? Is the brand proposition being

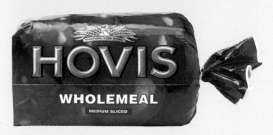

Hovis bread
Two elements of the marketing mix that supported Hovis' re-launch (2001): the award-winning packaging, designed by Williams Murray Hamm, and a sample of the fly-poster campaign.

Get
something
good
inside...

www. HOVIS bakery.co.uk

properly communicated? Is the brand properly differentiated from its competitors?

On the face of it, packaging design should be a cost-effective medium. Take a brand of hair care product. Nowadays the chances are that it will be sold through supermarkets, drugstore chains, and independent retailers—adding up to a large number of product facings. Each of these facings enables the "silent salesman" to go to work promoting the product.

In the past, when retailing seemed so much simpler, brands hadn't achieved their preeminence and the supermarkets did not have so much power over the market, product distribution was a matter of getting one's product listed and negotiating the right terms. Now competition for shelf space and position is huge. Product position in-store is paramount, and retailers have sophisticated methods for identifying primary, secondary, and tertiary selling spots. Product position on-shelf is all about gravitating upwards to the prime spots at the top of gondolas. Retailers charge for promotional positions, such as end of gondola displays. They also charge to have one's range displayed *en masse*, as a complete offer, undiluted by competitive comparisons.

It cannot be claimed that packaging, as an element of the marketing mix, is totally free in all cases because of these "listing" costs. However, in terms of "opportunities to see" (a term beloved by advertising agencies) and influence, packaging is hugely important, a point comprehensively proved in the section on design effectiveness (see page 26). Unfortunately, this does not always translate into design budgets that recognize the importance of packaging and the skills of packaging designers. I make no excuses for joining the ranks of other designers who lament the paucity of their budgets in comparison, say, to the advertising budget.

Setting aside the perennial budget gripe, good packaging designers use their understanding of the marketing mix when devising their packaging solutions. Sometimes this takes the form of challenging an aspect of the brief and asking whether a stated task is best achieved by another medium. Sometimes it results in a design solution that gives a brand owner a design device which can work across different media, in an holistic way. Understanding the amount of awareness that's going to be generated about a product through advertising, public relations, and so forth, also helps the designer understand the different degrees of "shout" and impact he/she is being asked to achieve in-store.

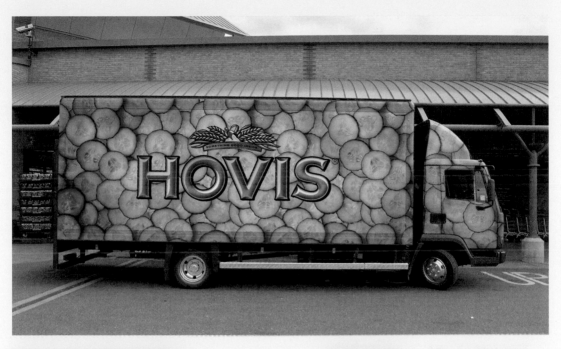

Extending the brand
Two more examples of the Hovis re-launch campaign, both of which take their inspiration from a core element of the packaging design—using images of typical bread accompaniments, like baked beans, and cucumbers. Designed by Williams Murray Hamm.

Local versus global

We are constantly being told we live in a "global village", to use US academic Marshall McLuhan's term. Geographic distances mean nothing now. Communication with any part of the globe is as simple as picking up the phone or sending an email. Leisure and news broadcasting brings the whole world into our homes. Consumers have access to products from countries on the opposite side of the world. Brands like Levi's, that were once unique to one market, are now ubiquitous, and marketeers measure the success of their products by international and not just national market penetration.

The seemingly relentless focus on the globalization of brands, products, and markets is not without its critics. Every time the big manufacturing nations, like America and Japan, hold a G8 Summit protesters take to the streets in often violent demonstrations. In 2000, Naomi Klein published a powerful indictment of globalization, *No Logos*, in which she states: "More and more over the last four years, we in the West have been catching glimpses of another kind of global village, where the economic divide is widening and cultural choices narrowing… This is a village where some multinationals, far from levelling the global playing field with jobs and technology for all, are in the process of mining the planet's poorest back country for unimaginable profits." Brands like Nike were roundly criticized for exploiting poorer nations' work forces in their bid to maintain manufacturing margins and market share.

Moreover, some nations persist in maintaining a national identity with strong local customs and tastes. They resist the homogenization of their individual worlds and treat with caution brands and products which prescribe a "world view". Understanding the issues surrounding the global-versus-local approach to markets is often difficult. Certain countries, or continents, react differently to colors, the style and content of images, and words. A French client of mine told me that Toyota had to rename the MR2 for the French market because the sound of MR Deux was too close to the word "merde", the French for "shit"—a not too flattering description for one's car. In Japan, there was no problem launching an ion supply drink called Pocari Sweat, and pronounced "Pokar Suetto", because sweat carries no negative connotations to Japanese people. In addition, certain factors, such as world events, can prejudice consumers towards a particular brand if the perceived parent country is deemed imperialistic. Nothing is simple in our global world.

Above right: Love biscuits
These Bauducco biscuits were designed for the Brazilian market. With names like *Sabor de Estrela* (Star's Taste), *Gotas de Amor* (Love's Drops), and *Gosta de Sol* (Sun's Taste), the designs are colorful and exuberant. The shapes of the biscuits themselves are intended to capture feelings like love, care, passion, joy, and energy. Designed by a10.

Below right: Cross-cultural
This packaging would not look out of place in any European or North American store. Its one acknowledgment of the local market is the brand's name in Chinese. This may well be because the brand is trading on local consumers' positive perceptions of Western products in this dietary product sector. Designed by Duffy Singapore.

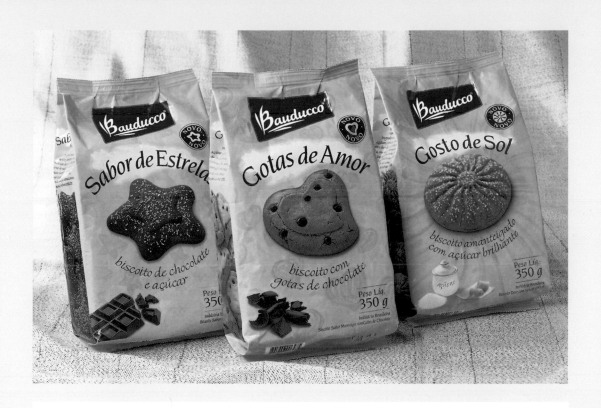

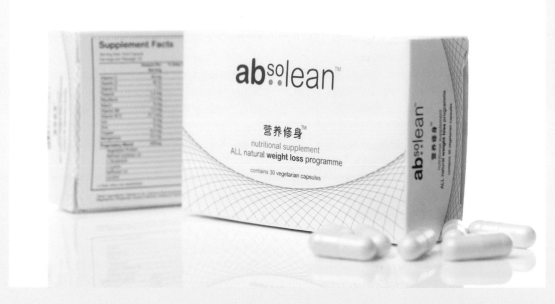

Defining global brands

Malcolm Baker and Greet Sterenberg, in their article *International Branding: Resolving the Global—Local Dilemma*, published in the UK journal *Market Leader*, (Winter 2002), offer some illuminating insights into this whole area. They say the need for localization will vary by the nature of the local culture and the brand's positioning—especially whether it has aspirational value—and divide global brands into three types, with two additional groupings:

01 Master brands
(Nike, McDonald's, and Visa)
A master brand's appeal is usually based on a powerful proposition or myth. They have a strong display and aspirational value. Typically, they have transcended their national origins. Master brands exploit innovation, rejuvenation, and persistent marketing to stay relevant and up-to-date. Because they are perceived as talismanic, they confer social power on their users. Consumers' relationships with the brand are based on a combination of authority (trust and innovation), approval (acceptability), and identification (bonding and nostalgia).

02 Prestige brands
(Ralph Lauren, Mercedes, and Gucci)
Prestige brands offer the best quality in their class, the notion of quality being rooted in a cultural myth about quality. Everyone believes that the Germans are the masters of engineering excellence. Consumers' affinity with this type of brand is based on authority (innovation and heritage) and approval (prestige and endorsement). Not surprisingly, this type of brand has a high display value with high aspirational value.

03 Global brands
(Dove and Nescafé)
These are brands which are often perceived as local offerings, although they are marketed globally. Usually they are in categories like food, household products, and personal care, with weak display value. Normally these brands have little aspirational value although in developing countries this can be different. Affinity with these brands is based on authority (trust and heritage) and identification (nostalgia and caring).

04 Tribal Brands
(Quiksilver and Mambo)
These are brands with a strong display value, that provide an individualistic alternative and are most attractive to younger, more sophisticated Western and Asian consumers, especially in fashion-orientated categories.

05 Super Brands
(Nokia)
These brands are usually available on an international basis and are different from master brands by being far more category than myth-driven.

The degree of localization a brand needs to adopt is based on the type of brand. Prestige brands need little localization, whereas glocal brands need the most. For both master and super brands, there is a fine line between responding to local markets, so that individuals don't feel part of an homogenized whole, and maintaining the global, and aspirational, nature of the brand.

To compound the complexity of this issue there are two other factors that come into play. First, localization is affected by category type. Categories like food, household cleaning, and

personal care—where factors like local taste and culture are important—require a lot of localization. In contrast, categories with a high display or aspirational value generally need less localization.

Secondly, some local markets have very particular values and traditions and this affects the degree of localization needed. To use Baker and Sterenberg's classifications: Cultural Individualists (like France) require localization and a strong connection with local consumers; Global Individualists (like the Scandinavian countries) have an openness to the world but require a strong, individualistic connection with a product; Global Sensitives (like Argentina and Chile) are, "Open to the world in a collectivist way… Making connections through global brands is often more important than pride in their own culture"; and Cultural Sensitives (like Mexico and India) expect global brands to understand and respect their unique cultures.

In *Marketing Aesthetics: The Strategic Management of Brands, Identity and Image* (1998), Bernd Schmitt and Alex Simonson further expand on the issue of local variations: "In East Asia, monolithic and endorsed identities are more common than branded identities. Large corporations are more trusted when they introduce new products and brand extensions than new start-up companies are. Therefore it may be necessary for a company with a branded identity structure to change to an endorsed identity when it enters East Asian markets… Proctor & Gamble, which uses a branded identity in the United States, has switched to an endorsed identity in Asia by changing two identity elements: its advertising, which ends with the Proctor & Gamble logo for each brand ad, and the packaging, which displays the Proctor & Gamble name in bigger characters than in the small print used in the United States."

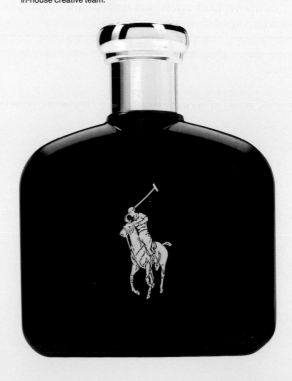

Epitome of brand cachet
Polo Ralph Lauren Blue is inspired by Polo's signature design. The design, with its royal blue bottle, silver cap, and Polo pony, embodies all of the brand's premium associations. Designed by Ralph Lauren with his in-house creative team.

Drinking the water

The more one works on international design projects the more one realizes how complex the global–local issue is. For designers it highlights the fundamental importance of knowing the product's status, its marketplace and its consumers. It is fundamentally about understanding all the factors that will affect a consumer's perception of a product and manipulating these to best effect. Writing in *Cross-Cultural Design Communicating in the Global Marketplace* (1994), Henry Steiner says: "Most people are unaware of their own culture—as they once were of oxygen, evolution, or gravity. Culture is our environment; it is the 'natural' way to think and behave, as unquestionable as water to a fish." Clearly, designers creating "glocal" packaging for cultures outside their own experience first need to drink the local water.

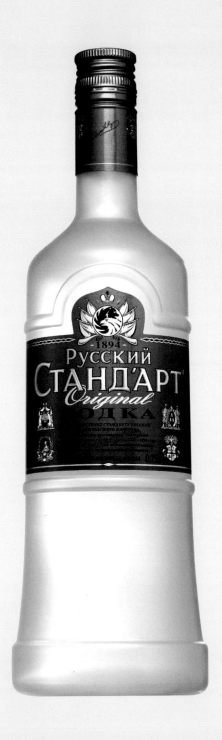

Global-local cocktail
Both bottle designs employ similar devices, like neck wraps, crests, and foils to communicate the authenticity and quality of the two different drinks—yet both capture the spirit of two quite different countries. Both illustrate the characteristics of a "prestige" brand. Ballantine's designed by Lewis Moberly, and Russian Standard Vodka by Identica.

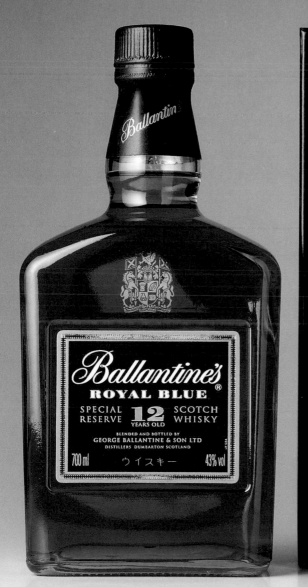
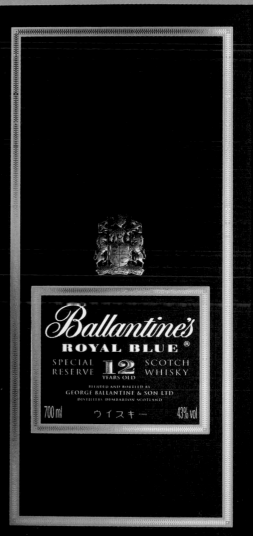

Measuring packaging design's success

Packaging design, like all design, does not operate in a vacuum. Designers are given a task, or tasks, that reflect the aspirations of the brand owner—such as increased sales, higher profits, greater market share, reduced packaging costs, faster market reactivity, increased distribution, re-focused consumer perceptions, or new product introduction—and they set out to achieve this objective.

One of the particular strengths of packaging design is that its effectiveness can be measured quite easily in contrast to some other design disciplines. Sales of a product can be measured, for example using Electronic Point of Sale (EPOS) data, before a new piece of packaging design is introduced and then measured after its introduction and the results compared.

A product's retail pricing, manufacturing, and packaging costs can be adjusted as part of a packaging redesign initiative and the sales results analyzed to measure increases in profit ratios.

A brand's market share can be measured on both a macro—such as national—and a micro—such as regional—level, prior to a redesign, and then measured again to see increases in brand share comparative to its previous share and to the competition.

A product's structural packaging can be analyzed to identify opportunities for cost savings through the use of new formats, substrates, and manufacturing methods to see how its design can be changed as part of a redesign process. This can also look at the whole manufacturing process to see whether formats currently requiring heavy manual intervention can be automated. It can also look at a product's packaging from a display point of view to see if adjustments can be made to counter shoplifting or product wastage because a consumer has removed a product and ruined the packaging, making it unsaleable.

A product's Direct Product Profitability (DPP) can also be addressed to see if improvements can be made to its size—so reducing the amount of display space it takes up—and to its warehousing and transportation, either solely or in bulk, in an effort to improve its profitability.

Certain markets are highly susceptible to fashion and tastes, and the designer's task is to create a design solution that enables new product designs to be introduced quickly and cost effectively. In some cases, this market reaction is determined by seasons, in others by responsiveness to competitive activity. Either way, a packaging solution that takes ages to change and is costly to produce defeats its purpose. Any packaging solution that is quick and effective proves its worth very quickly.

Packaging design can also be exploited to increase a manufacturer's distribution. Retailers may be refusing to list a product because its current design is too old-fashioned, too out of synch with certain markets, or packaged wrongly for a particular retailer's merchandizing formats. Design can address these issues and is measurable by the simple expedient of counting new retailer listings, or by new foreign markets opened.

Of course other factors—such as the retailer margin being offered—may affect a product's new distribution channels but if all things were equal and the only change was the packaging design, its impact can be measured.

Repositioning a product is a difficult task but often necessary with sales and distribution falling, as advertising and sales promotion initiatives fail to have an affect. In the hands of experienced and gifted designers, a brand's positive equities

22 LOADS

WASHING LIQUID
FOR FINE FABRICS
& WOOL

WOOLMARK®

ECOVER®
DELICATE WASH

the power of nature

32 fl oz 946 ml

| **1** SAFE FOR ALL HAND WASHABLES | **2** KEEPS COLORS BRIGHT | **3** IDEAL FOR BABY CLOTHES |

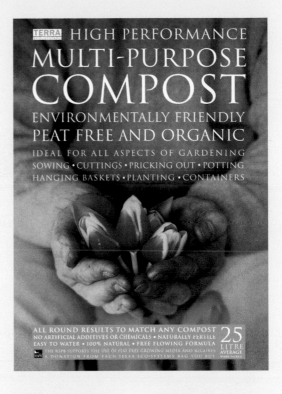

Left: Product integrity
When Ecover redesigned its packaging it was looking to attract both "dark green" and "light green" consumers. It wanted these consumers to appreciate the integrity of its cleaning products and to understand that the products are based on plants and mineral ingredients. It also wanted the brand to compete in its category and have strong on-shelf stand-out. Since the re-launch, consumer reaction has been unanimously favorable, and the individual products are seeing turnover rises of between 20 and 25 percent. Designed by S-W-H, working with Pam Asselbergs and Alex Scholing.

Above: Fertile ground
The redesign of Terra EcoSystems whole product range resulted in sales 961 percent greater than those after the original launch. In addition, in 2001, 60 percent of sales were to new stockists. As the only major marketing changes were to the packaging and literature, the success of the re-launched product can be laid squarely at design's door. Designed by Glazer.

can be identified and absorbed into a new design solution, whose effectiveness can be measured through both sales data and consumer research.

Lastly, for a huge plethora of product launches, particularly retailers' own products, marketing budgets do not exist and a product's success rests on the effectiveness of the packaging design, and of course the product itself. Packaging design comes into its own in these situations, proving by its success its ability to communicate and engage with consumers, and influence their purchasing decisions.

Hard data underpins design's effectiveness. It's also a powerful advocate for seeing design as an investment—an investment generating a return, just as new product development generates a return. Lippa Pearce, like many other designers, has worked on projects where the design payback period can be measured in weeks.

Another way of looking at design as an investment was proferred by Martyn Denny, sales and marketing director of Aqualisa, in The Design Council's *Facts and Figures on Design in Britain 2002–03*: "If you think good design is expensive, look how much bad design costs."

Right: Herbal remedy
Following the redesign of Dr Stuart's Botanical Teas, sales in the UK, rose by 65 percent—in a market which was only growing at 12 percent. Furthermore, the range is now listed in all of the major UK multiples, has entered new markets in Italy, France, Norway and Russia, and has seen sales double in the USA. Designed by Sheppard Day.

Below: Score!
So succcessful was the packaging design for Carling Black Label's special edition cans that the product sold out in a matter of hours. Designed by Enterprise IG.

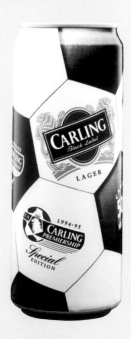

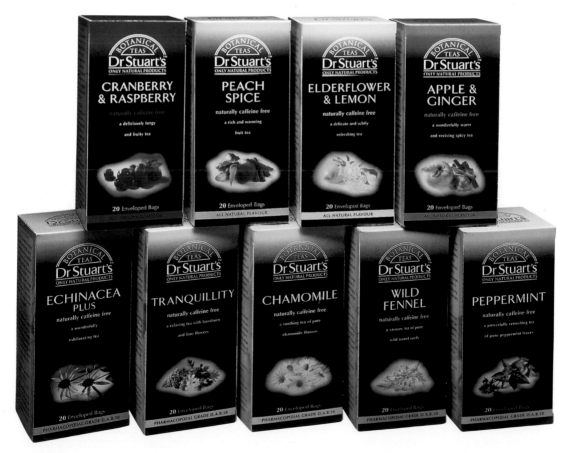

The retail environment

I previously remarked that packaging design does not operate in a vacuum, and this is forcibly demonstrated by packaging's natural environment—stores. Big or small, independent or chain, department or emporium, specialist or generalist, all stores are the primary vehicle for manufacturers (brand owners and retailers) to present their products to the consumer.

I am aware, of course that there is another shopping vehicle, the Internet, but it is probably fair to say, with the exception of some notable players, like Amazon, that it is still in its infancy. The Internet has not lived up to the expectations of the early pioneers—nor the expectations of those unfortunate investors who ploughed their money into "clicks" over "bricks"—and in volume terms cannot compete with "traditional" shops. Moreover, most e-retailers have not yet come up with a way of selling products on-line without displaying a physical representation of the product. Visit most sites and you find pack shots representing products.

The modern retail world of "bricks and mortar" is a very dynamic place where established practices are questioned and new formats trialled. The concept of the "consumer experience" has taken root. Stores like Niketown and Selfridges offer shoppers an environment far removed from the row upon row of shelving, the notion of space optimization and maximization of sales per square foot.

Some things never change, of course. Anyone who has ever stood in line for hours at an IKEA store knows that shopping may be fun but the payment process can be torture. In the case of packaging design, some things are constant while others are changing. Consumer choice is now a given and, as a result, speed of selection is an issue. Choice doesn't necessarily go hand in hand with consumer awareness, so self-selection and assisted self-selection, are concepts retailers must consider to ensure the right balance of consumer focus and customer services.

Choice also lies at the heart of the first topic considered in this section—the development of own brand. Retailers know their power. They exercise it every day over their suppliers. If the big supermarkets in the UK are anything to go by, they also know the power of their brand. On one level, this directly effects packaging design because of the sheer scale of design activity: in a year, such stores may design or redesign in excess of a thousand products.

Packaging's natural environment
Two store views, one from the US (above) and one from the UK, showing packaging in typical supermarket environments. Both illustrate the choice facing consumers at a category level.

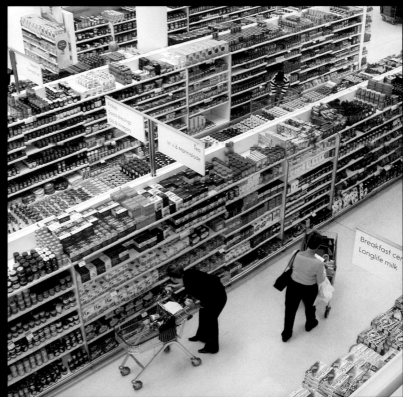

Proprietary versus own brand

What do we mean by proprietary versus own brand? On one level, it encapsulates the competition between proprietary brands—like Heinz, Persil, and Coca Cola—and retailers' own brand offers. Most major supermarket retailers now have an own brand offer and, depending on the size of their total product inventory, this may vary from 30 percent to as much as 60 percent. In the UK Marks & Spencer, more department store than supermarket, is 100 percent own brand. In real terms this can mean that a retailer is managing an own brand portfolio of several thousand products, each one constantly being reviewed to ensure it competes effectively with its proprietary equivalent.

Competition in this context is between one product and another, between a retailer's product, with its higher profit margins, and a proprietary brand. Given this competition, brand owners and retailers live in a world of mutual coexistence, punctuated only by occasional disagreements.

Sometimes disagreements occur because a retailer crosses the line and produces a "copy-cat" design. Often derisively known as "me-toos", these designs ape the proprietary brands by borrowing the brand's distinctive visual equity: it may be a color—as was the case when Sainsbury's launched its own cola in red cans; or it may be a name—when Tesco launched a spread called Unbelievable in the same market as I Can't Believe It's Not Butter!, it incurred manufacturer Unilever's wrath; or it may be a character—such as the McVitie's penguin which appears on its much-loved chocolate biscuits. In the UK, Asda was forced by the courts to remove its puffin character from its Puffin chocolate bars because these were considered to be imitating the proprietary brand.

The British Brand Group estimates that more than two million shoppers buy copy-cats each year by mistake, which amounts to a loss of £9.3 million a year for brand manufacturers. Sometimes the imitators are so successful, a brand is irreparably damaged. French manufacturer Bonne Maman's distinctively shaped jar has been so copied by retailers that it has suffered badly. Had Bonne Maman trademarked its jar shape, it could have protected itself.

At Lippa Pearce, we hate being asked to emulate an existing brand. Not only does it undermine everything we believe in (the power of design, the uniqueness of the proposition, our own creative skills) but it smacks of a complete lack of confidence on the part of a retailer in its brand and its offer.

Saks Fifth Avenue
A perfect example of a retailer confident in its own brand offer and producing packaging that has a high perceived value. Designed by Slover [AND] Company.

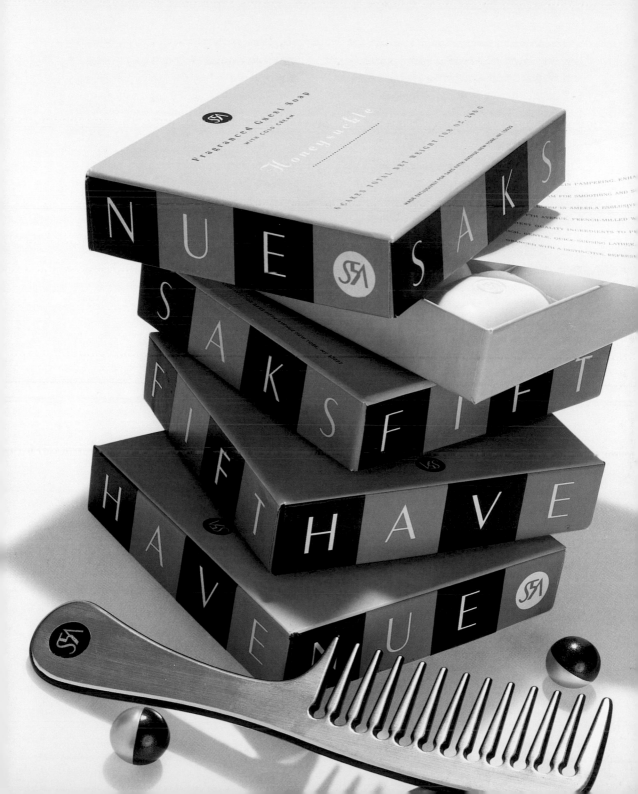

This lack of confidence is surprising because there is one other dimension to the proprietary versus own brand issue. In the 1970s, there was a UK supermarket chain called International Stores. I can still remember the look of its own brand offer. Simple and utilitarian in design, the packaging did little more than tell you the name of the product using plain white packaging. In the 1980s, I experienced an echo of this while living in Canada. Loblaws, one of Canada's supermarket chains, had a similar "value" approach to its own packaging. All of its packaging employed a distinctive yellow color. Both retailers' attitude to their packaging was more own label than own brand. This may seem like semantics but own label best sums up an approach based on just offering the consumer a cheaper alternative. In contrast, own brand suggests that a retailer has woken up to the fact that it is a brand in its own right, with its own values and personality.

This realization has led to many retailers investing considerably in refining their brand proposition, segmenting their product portfolios and investing in good design. Some retailers segment their portfolios into "good", "better", "best" categories, and invest time and energy commensurate with the value of each categrory. Another retailer we have worked with segments its products into "generic", "brand alternative", and "added value".

Some own brand owners refer to added-value products as "power brands". It is a term that carries many definitions, but in the retail context power brands are developed to focus consumers' attention on the brand. They have a "halo effect" where their intrinsic power influences consumers' perceptions of the overall brand. For example, a retailer may introduce a power brand which is extremely contemporary and innovative, which contributes to changing consumers' negative perceptions of a retailer brand, or even attracting new consumers.

The development of own brand, as opposed to own label, has led to many exciting developments in packaging design. Interestingly, it adds another component to the design brief because, like sector behavior (see page 54), and market positioning (see page 58), it provides a focus for the design work. Knowing a product is a brand alternative provides the competitive context. Knowing a product or range is added value gives you more scope as a designer to explore how the packaging design will contribute to perceptions of the brand as well as communicate the proposition powerfully.

Distinctively upscale
More own brand packaging for Saks; this time for its premium gifts food line of cookies, truffles, and candy-nut assortments. This one-color design achieves the right effect through the use of hand-rendered icons of wrapped gifts and champagne glasses, and a gold/bronze signature color. Designed by Sayles Graphic Design.

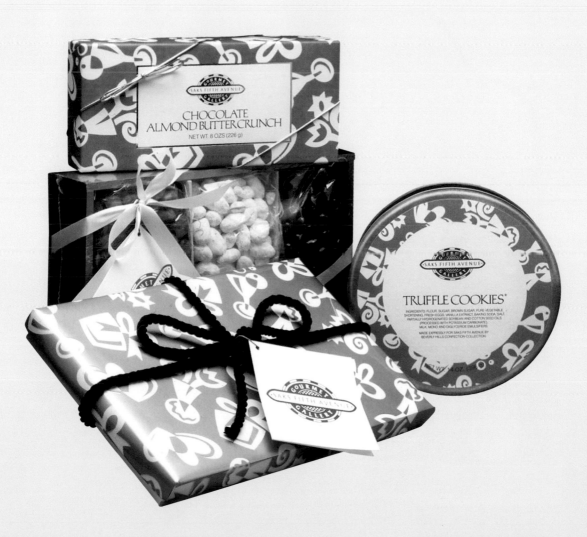

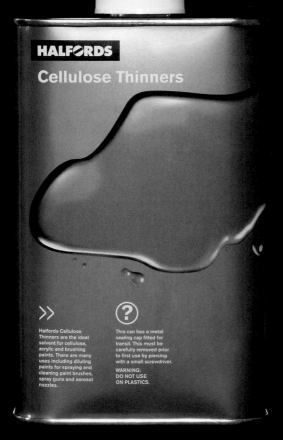

HALFORDS
Cellulose Thinners

Halfords Cellulose
Thinners are the ideal
solvent for cellulose,
acrylic and brushing
paints. There are many
uses including diluting
paints for spraying and
cleaning paint brushes,
spray guns and aerosol
nozzles.

This can has a metal
sealing cap fitted for
transit. This must be
carefully removed prior
to first use by piercing
with a small screwdriver.

WARNING:
DO NOT USE
ON PLASTICS.

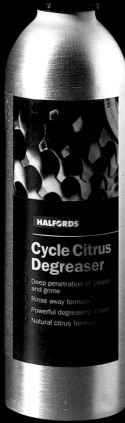

HALFORDS
Cycle Citrus Degreaser

- Deep penetration of grease and grime
- Rinse away formula
- Powerful degreasing action
- Natural citrus formula

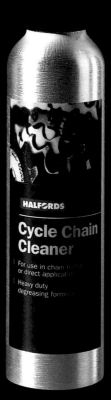

HALFORDS
Cycle Chain Cleaner

- For use in chain baths or direct application
- Heavy duty degreasing formula

HALFORDS
Front Reflector

BS 6102

Conforms
to British
Standard BS
6102 Part 2

Integral
attachment
bracket

Wheel Reflectors

BS 6102

Conforms
to British
Standard BS
6102 Part 2

HALFORDS
Rear Reflector

BS 6102

Conforms
to British
Standard BS
6102 Part 2

Integral
attachment
bracket

HALFORDS
Mudguard Reflector

BS 6102

Conforms
to British
Standard BS
6102 Part 2

Complete
with fixing
screw

Suitable for
rear mudguards
with two
fixing holes

User-friendly

The products on this page represent a small sample of the packaging design commissioned from Lippa Pearce by Halfords. Each has been designed to help the consumer select the right product for his or her needs. Product features and benefits are communicated, either graphically or typographically, in a simple direct, fashion. All of Halfords' packaging shares this distinctive, user-friendly approach and it works. The motor oils (bottom right), which were designed by Pentagram and Lippa Pearce, won both a DBA Design Effectiveness and a *Retail Week* Award in 1996. Halfords was complimented by the *Retail Week* judges for being an outstanding example of a retailer sure of its brand and not afraid to take on the branded competitors. The motor oils project was done in collaboration with Pentagram, and the LED lights project was done in collaboration with AM Associates.

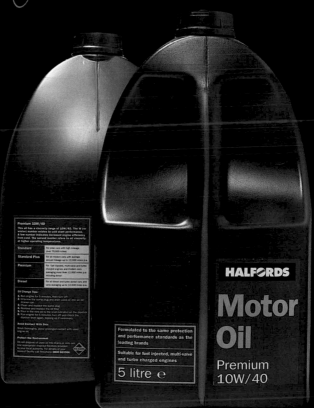

Speed of selection

In 1972, John Berger wrote in his seminal book, *Ways of Seeing*: "In the cities in which we live, all of us see hundreds of publicity images every day of our lives. No other kind of image confronts us so frequently. In no other form of society in history has there been such a concentration of images, such a density of visual messages." Thirty years later, in *Unique Now… Or Never*, Jesper Kunde writes: "Research shows that an ordinary citizen in the western world receives 3,000 marketing messages each and every day… The noise is deafening."

As consumers, we experience Berger's "density of visual messages" each time we visit a store. On entering, we are met with a kaleidoscope of products and merchandizing displays: row upon row of products. The average consumer, if such a person exists, looks at the retail display and sees choice, and more choice. She or he sees brand, product, flavor, usage, price, and size choice, to name but a few of the selection criteria. Faced with such a plethora of products rational and emotional factors kick in, not to mention the distraction of a partner who thinks shopping is torture not therapy, and children who've set their minds on making life hell. These factors kick in fast—the belief is that consumers spend no more than a few seconds initially looking at a product.

The human brain's ability to cope with such a melange of images and competing messages, sometimes described as "white noise", is extraordinary. Much research has been undertaken trying to understand the process consumers go through when looking at a product display and individual products. Suffice to say, "white noise" challenges packaging designers. How do we cut through the visual clutter to achieve distinction? How do we create a visual presence which attracts consumers' eyes and tempts them to look beyond their familiar visual references—the cereals they always buy, the shampoo they feel most comfortable with? How do we present rational reasons to buy—this product will style your hair, making you look good—or emotional reasons—this product will make you feel sexy—in a powerful way… all in a few seconds?

In short, designers achieve this "cut-through" by working with their clients to create strong product propositions and then visualize these in as simple and effective a manner as possible. Packaging's primary face, the part that is visible on-shelf, should engage with consumers, attracting notice, and triggering consideration. This is not to say that the core proposition cannot have layers of substantiation, but these should be communicated via the rest of the packaging.

According to Schmitt and Simonson: "In communications research a distinction is made between two kinds of messages, the central message and the peripheral message. The central message refers to the main persuasive issues or arguments and the peripheral message refers to all other tangential elements that are not attended to as the main message cues". Focusing on the central message lies at the very heart of good design. Paul Rand, one of the most influential figures in US design, used to teach his students about the primacy of the concept and taught them that if they couldn't write down the idea behind their design on one side of a small index card they didn't have a design.

Don't look now
Trying to cope with the
density of visual messages

Self-selection and assisted self-selection

Most modern retailing is self-service, but modern retailers now talk about self-service and assisted self-service in recognition of the needs of different consumers and the varying behavioral patterns in different sectors. Retailers categorize consumers, giving them names like "time starved", and devise retail formats to ease their shopping experiences. For example, Kesko in Finland has divided some of its city and town stores into zones. A zone at the front of a store, which customers in a hurry can access easily, stocks "top-up" products. Zones further in the stores cater to the needs of weekly shoppers. Many retailers now have sections designed specifically for shoppers buying only a small number of items in a hurry, complete with "fast-track" checkouts.

Retailers also classify consumers by their category confidence. One of our clients, the owner of a multi-million-pound own-brand range, segmented its skincare and cosmetic target market into "perfection strivers", "confident all rounders", "inspiration seekers", and "beauty junkies". Another client, a retailer of car and cycle parts and accessories classifies two of its customer segments as "mechanical enthusiasts" and "accessory enthusiasts".

Retailers also now recognize shoppers' different moods and modes. Sometimes they are browsing idly. Sometimes they are shopping with friends and sharing new product discoveries. Sometimes they are "mission-focused"—their desire is simply to do the shop.

Consumers also change their purchasing behavior, depending on which product category they are buying from. Research undertaken a number of years ago identified that consumers buying suncare products can spend up to an hour assessing the products on offer and selecting the right product for their skin type. In other sectors, such as healthcare, consumers' over the counter (OTC) purchasing decisions often take longer based on the seriousness of the condition needing treatment. In a category like dietary products, where consumers are calorie-counting, purchasers often go through a "complex" process of weighing up need, allowance, taste, and commitment.

In some sectors, assisted self-service is the norm. Due to the choice and complexity of products on offer, specialist staff are normally on hand to assist the consumer, assessing their needs, taking them through the options… and encouraging higher spend. During a research session I attended it became clear that in some areas, like cosmetics, these specialists are viewed with some trepidation.

Understanding consumers' purchasing behavior and mind-sets is invaluable when creating packaging design solutions. Knowing consumers want help selecting the right product forces designers to present information in a clear way. Knowing consumers don't have time to interpret complex range hierarchies helps designers create on-pack design features that differentiate the role and function of a product. Understanding the role of an assistant in the purchase decision disciplines designers to be logical and consistent in their portrayal of product features, benefits, and usage instructions.

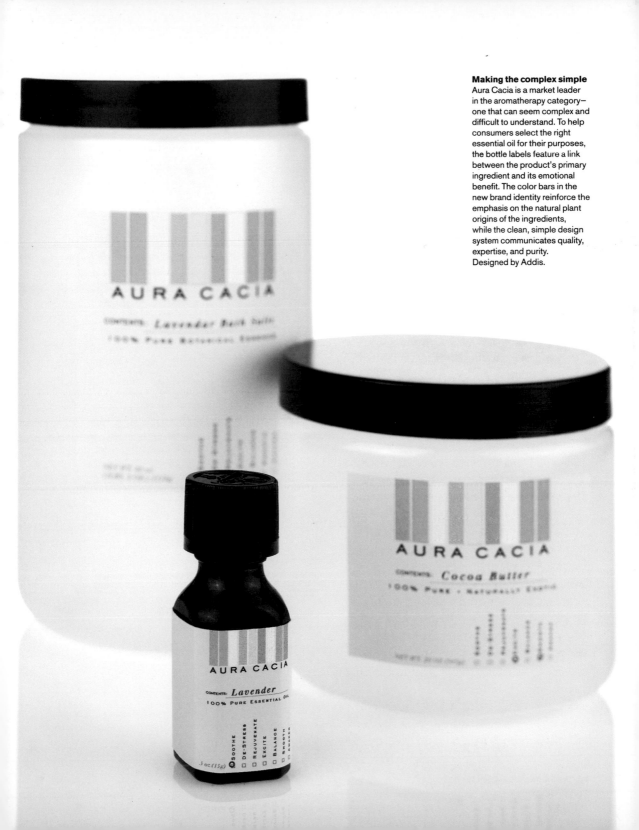

Making the complex simple
Aura Cacia is a market leader in the aromatherapy category— one that can seem complex and difficult to understand. To help consumers select the right essential oil for their purposes, the bottle labels feature a link between the product's primary ingredient and its emotional benefit. The color bars in the new brand identity reinforce the emphasis on the natural plant origins of the ingredients, while the clean, simple design system communicates quality, expertise, and purity.
Designed by Addis.

AURA CACIA

CONTENTS: *Lavender Bath Salts*
100% PURE BOTANICAL ESSENTIAL

AURA CACIA

CONTENTS: *Cocoa Butter*
100% PURE · NATURALLY EXOTIC

AURA CACIA

CONTENTS: *Lavender*
100% PURE ESSENTIAL OIL

○ SOOTHE
□ DE-STRESS
□ REJUVENATE
□ EXCITE
□ BALANCE
□ SMOOTH

.5 oz (15g)

Packaging dynamics

Packaging performs its different functions within a myriad different retail sectors and a whole host of retail configurations. At a basic level, however, some things never change and these are the things packaging designers should be aware of. These things may best be described as "packaging dynamics".

Packaging dynamics are important because they reflect consumers' basic needs. They tend to stay constant because consumers' needs stay constant. Faced with a range of products to choose from, consumers either fall back on experience when selecting the right product (namely, "What did I buy last time?") or are influenced by visual merchandizing, sales promotion activity, or packaging design. In this context, product differentiation is important and any packaging design solution must make it easy for consumers to select the right product.

From a design perspective, this means that a packaging brief will be a composite of tasks relating to a particular product and a set of "generic" tasks that will be important because their completion will ensure Brand X will be given proper consideration. For instance, a design brief that involves redesigning a major range of cosmetics: the particular task will be to ensure the brand's proposition is communicated meaningfully; the generic tasks will be to ensure that products within the range are properly differentiated, the range is positioned accurately in the market place, and that the packaging sits comfortably, and appropriately within its sector.

Vive la difference
Making sure Brand X is given proper consideration.

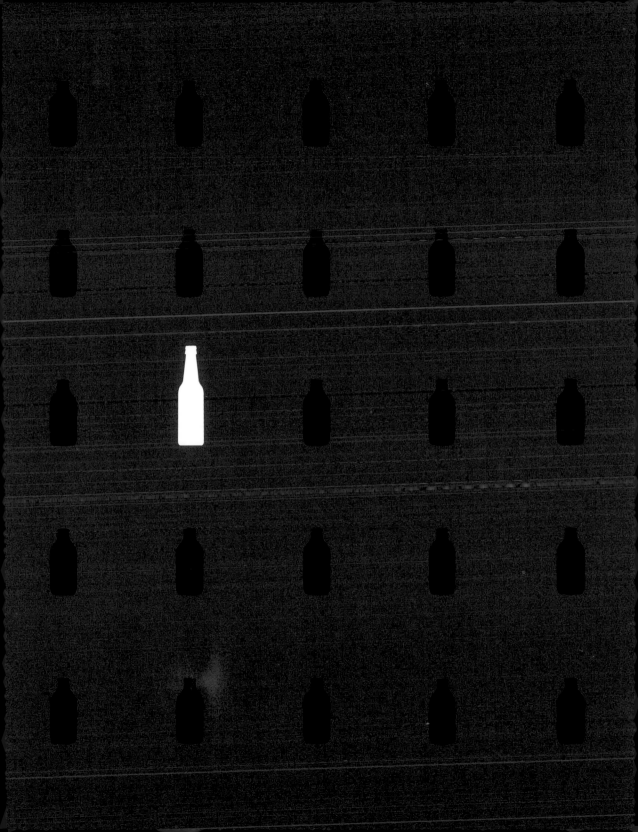

Brand manifestation

I still remember the first time I had a bottle of Coca Cola. It was a boiling hot day in Malta and I was no more than five years old. Despite the fact it was nearly 40 years ago, I can still remember my excitement at the prospect of having my first Coke and the feel of the ice-cold bottle in my hand. The bottle of Coke and the memory are inextricably linked, so much so that the bottle–the packaging–has become symbolic of the brand and the experience.

Many consumers have similar relationships to brands. Although Heinz has now introduced its ketchup in squeezable bottles, making it easier to dispense its tomato sauce, for many people the new bottle carries none of the emotional resonances associated with having to bang the bottom of the glass bottle and wait expectantly for the sauce. The packaging becomes a manifestation of the brand itself and, because a brand is more than just the product itself, the packaging becomes a compound of consumers' perceptions, memories, and feelings. In effect, a brand becomes a compound of "tangible" and "intangible" values, the latter being formed in consumers' minds.

By understanding this particular role of packaging, designers can try to manipulate consumers' perceptions of a brand. With older brands, consumers' perceptions may well be ingrained and the task is to make sure that a brand's packaging reflects these perceptions. In the case of younger brands, packaging design can be manipulated to portray the intangible values you want the brand to have. At this stage, it is very important to define these values and communicate them because there will come a point when a subtle shift takes place and a brand's values become what consumers believe them to be–you no longer control them.

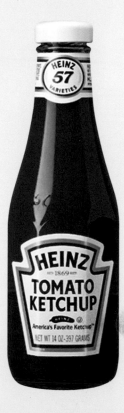

Left: Think ketchup, think Heinz
Few products are as inseparable from their packaging as Heinz Tomato Ketchup. The shape of the bottle, the wait for the ketchup to slowly pour out, the "keystone" label, the 57 varieties, and the green pickle are all things we associate with the brand. In time, the packaging has become synonymous with the brand. Designer unknown.

Right: Jean Paul Gaultier Classique
Classique is a perfect example of packaging as a manifestation of the brand– in this case, the brand is Jean Paul Gaultier. The wit and sexiness that I associate with the designer is brought to life in packaging that shares these characteristics. Designed by Jean Paul Gaultier.

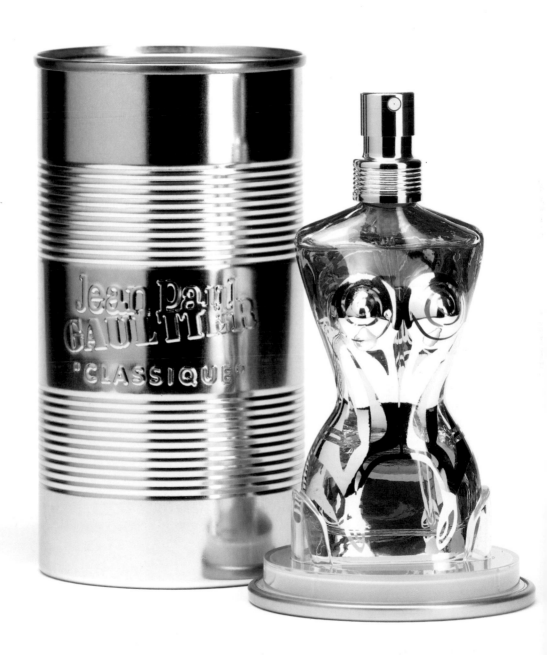

Product differentiation

Why is product differentiation so important? Perhaps this passage from Jonas Ridderstråle and Kjell Nordström's book *Funky Business: Talent Makes Capital Dance* (2000) offers some insight: "1996 saw the publication of 1,778 business books in the American market. Major record label companies launched 30,000 albums in the US in 1998. In the same country, the number of grocery product launches increased from 2,700 in 1981 to 20,000 in 1996. To keep up with all the product launches, Procter and Gamble has more scientists on its payroll than Harvard, Berkeley, and MIT combined… In 1996, Seiko launched 500 new products—more than two new products per working hour. Maybe this is necessary in a market where the average product lifecycle for consumer electronic products is now three months. Still, compared to Walt Disney, Sony's innovation record is nowhere. Disney's CEO, Michael Eisner, claimed that the company developed a new product—a film, a comic book, a CD, or whatever—every five minutes".

Consumers' expectations of choice are now so high that retailers have responded in a host of different ways. Selfridges, in London, has now positioned itself as a "house of brands" and offers shoppers a host of world-leading brands in a wide variety of categories, in an environment that truly is a consumer experience. Retailers like Walmart in America and Carrefour in France have taken the large-store format to a size unimaginable 50 years ago.

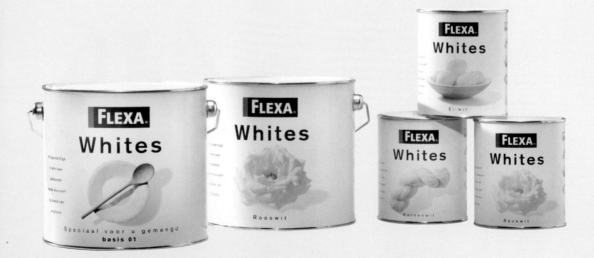

Below left: White lines
There's white and then there's white. I think it was Anouska Hempel who said white was her favourite color because there are so many whites to choose from. Flexa's solution to differentiating its whites is to use strong, beautifully shot images that capture the tone of the respective whites, and then set them in a simple layout that lends focus to the imagery. The treatment not only differentiates the product but very neatly distinguishes the brand from its competitors. Designed by Mountain Design.

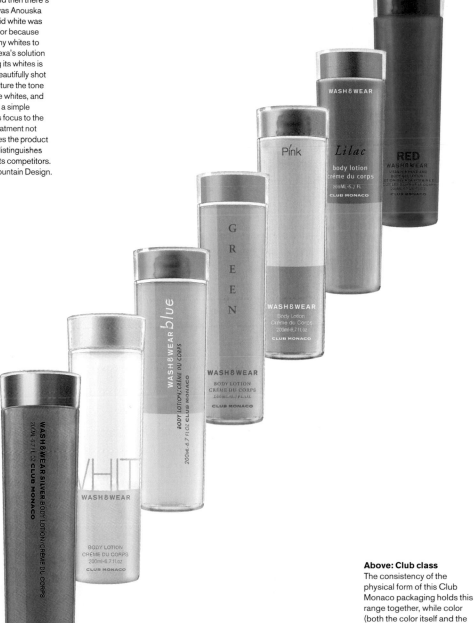

Above: Club class
The consistency of the physical form of this Club Monaco packaging holds this range together, while color (both the color itself and the color name) and its use differentiate each product. Designed by Sayari Studio.

At a category level, like skin or hair care, consumers can choose from a wide variety of products designed to cater for individual skin or hair types. Indeed, product choice is now a factor in consumers' perceptions of a retailer's particular brand credentials. Understanding the amount of choice a consumer has is very important. It provides the context for design and illuminates the scale of the task. It's important to know how many competitive products will be displayed with the one you are working on so that you can truly understand the competitive set. It's also helpful to understand the make-up of the competitive set. There may be one or more market leaders with established brand equities or it may be a relatively immature market sector with no brand leader. Either way, your product needs to stand out and be clearly different from its competitors.

Typically, the need to differentiate one product from another results in clients talking about shelf impact and product stand-out in their briefs. Designers are asked to make the product "shout", thus attracting consumers' attention. Unfortunately, if every product shouts, the shelf becomes a cacophony. Achieving on-shelf impact is therefore not about making as much noise as possible. If it was, packaging design would probably consist simply of flashes, starbursts, large bold type, and eye-catching colors. Instead, it's about creating a meaningful product proposition and communicating it in a manner that has a powerful resonance with consumers.

Of course, arriving at a powerful, distinctive product proposition is not easy, especially when there may be little actual difference between products. In the past, the notion that a product had to have a unique selling proposition (USP) held great sway: indeed

a product's USP defined it. In recent times new theories have evolved based on a product's Emotional Selling Proposition (ESP) being a powerful differentiator.

Whether one develops a powerful USP or ESP, or even a combination of both, the objective is the same. As Kunde says: "In such a crowded market there is no point in competing for shelf space or simply making more noise. You have to differentiate your offering. There is only one place in which you are (or should be) interested in being taken seriously, being heard, noticed, registered, remembered, used. That place is the human mind. That is where you must strive to grab some space".

Design's primary role in product differentiation is to give substance to a product's proposition and to exploit every feature of its packaging to engage with consumers, whether this be through imagery, color, language, shape, format, or even the tactile quality of the packaging's materials.

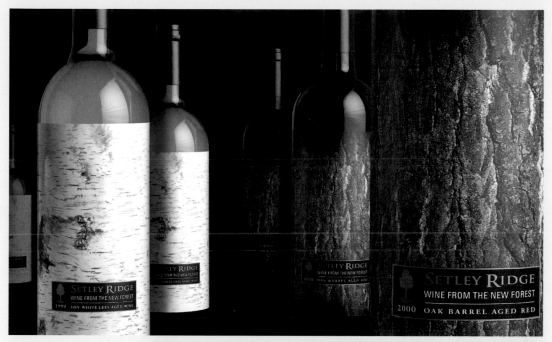

**Above: Message
on a bottle**
Taking their cue from the core
proposition (wines from the
New Forest), Setley Ridge's
wine labels imaginatively
differentiate themselves
and reinforce the proposition
at the same time. Designed
by Enterprise IG.

Right: Vitality in a can
In complete contrast to the
competition, Denes Pet
Foods eschew stereotypical
color images of dogs in favor
of a cartoon character on a
simple white background. The
effect is to focus consumers'
attention on the image's
message—a dog full of vitality
and character. As a result, the
design immediately interacts
with that most powerful of
relationships—the one that
exists between pet and owner.
Designed by Blackburns.

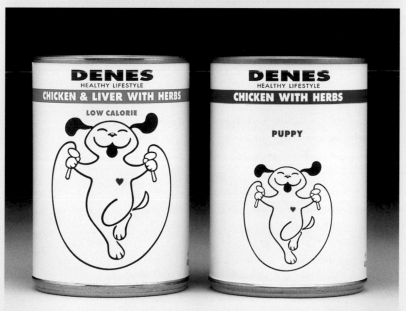

Ranges and solo products

In simple terms, products can be divided into solus items and ranges. Designing solus items, such as a fragrance or a box of chocolates, is primarily driven by the need to differentiate and sell that product within its particular sector. Designing product ranges adds other layers of complexity to the process.

Sometimes the complexity lies in the need to communicate the breadth of the range, and then help consumers select the product that is right for them. When a range consists of four to five products, this is relatively simple. However, when a range consists of hundreds of products, like the Halfords Car Paints (see page 203), the task is more complicated. The US company M·A·C (Make-Up Art Cosmetics), for example, has 140 lipsticks in its range.

In some respects, the task is made easier because the products are displayed together and consumers can perceive the difference within their immediate field of vision. Aided by the packaging, the consumer can then decide whether he or she wants a particular flavor, product action, color, etc.

In other situations, ranges may well be spread across a category or across categories. Not many brand owners have the financial clout to pay retailers' premiums to have all of their products displayed together in a prime gondola position—in the process achieving a powerful "brand presence". Indeed, in categories where consumers actively compare products, this may prove detrimental. If your product doesn't appear in the category merchandizing, you cannot presume a consumers will hunt it down in your brand-specific section.

As result, a range may well be dispersed across a category (for example: spread across shampoos, conditioners, stylers, and hair

Full-color spectrum
At the end of the day, it's the lipstick itself rather than the packaging that differentiates one product from another, and it's a constant challenge for cosmetic brands to create lipstick packaging that protects the product and makes it easy to display the product on cosmetic counters. When you have 140 lipsticks to offer, like M·A·C, the solution lies in clear plastic tops, color coded labels on the base or merchandising the products without their tops. Designed by Frank Toskan, and originally developed by Hsing Chung (a Chinese manufacturer) and Thorpe (a collaborative company).

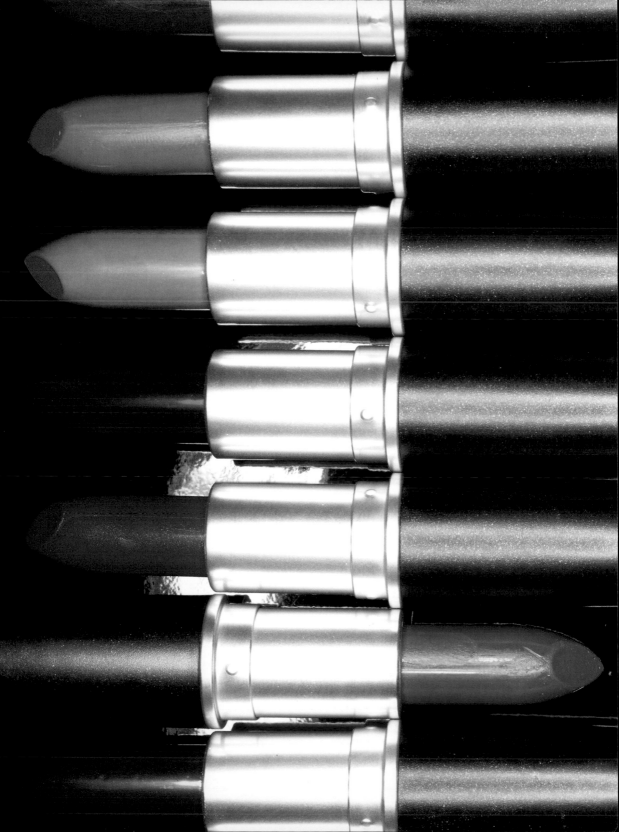

treatments within haircare) and the brand presence diffused. In other cases, a range may well be spread across categories as wide-ranging as the many categories that exist, for example, in food retailing.

In these latter two cases, the issue is less about product selection and more about brand recognition and presence. A brand owner or retailer wants its brand to compete in an individual sector but it equally wants its brand to have a cumulative presence. Why? Because brand presence communicates brand authority and expertise. How this is done lies within the remit of the designer. It's a challenge different designers meet in a variety of ways. It can be enough to create range presence through the use of color, or a particular photographic style, or through the development of particularly distinctive structural packaging, or even a graphic device. The essential point though is that design briefs carry many areas of complexity and this is just one more. As an illustration of this, Lippa Pearce was recently given a brief which asked us to: "Improve stand out; create a clear communication hierarchy; improve benefit communication; adhere to category norms; explore options to introduce premium and emotional cues; and create a distinctive and relevant visual mnemonic to provide brand identity."

Right: The complete picture
Each of these Winsor and Newton Ink packs represents a different color in the tonal range, and each is engaging and involving in its own right. Indeed, each is a triumph of the art of illustration itself. Put together, they are like a collection of short stories. The range is irresistible on-shelf and packed with authority. Designed by Identica.

Below: Vibrant colors
Here. the strength of the image style and content holds this Vidal Sassoon range together as a coherent unit and provides it with its authority. Consumers' confidence in choosing the product they want is aided by the photographs and color definition panels on the lids of the cartons. Designed by Dew Gibbons.

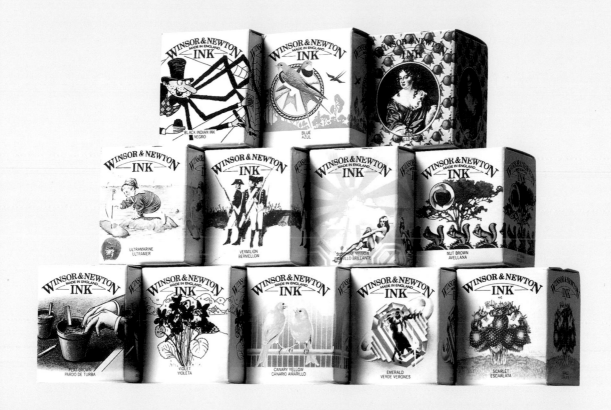

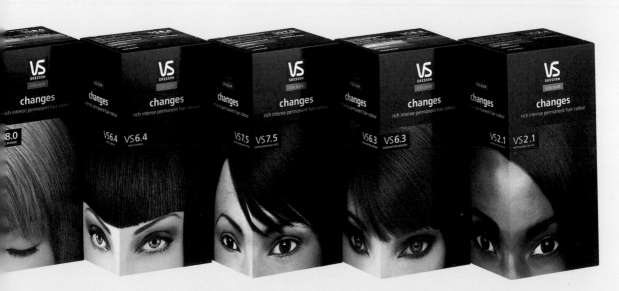

Sector behavior

Every market sector behaves in its own way and, over time, this behavior can result in strong visual language. Some people call this language "sector cues" while others, like Southgate, call it "category equities". As he says: "Brands exist in particular competitor repertoires, and these act as the frame of reference within which each brand operates. Often these repertoires will have developed over the years—whether by accident or design—particular visual languages, or category equities: these impose certain constraints within which the communication of our own distinctive brand values must take place. Ignore too many of these category equities, move too far away from the established visual language, and you run the risk that you will have moved outside of the consumer's frame of reference. Your brand will simply be overlooked because it no longer belongs to the set".

Sector behavior is important in design because it provides a frame of reference. Just as market positioning helps consumers relate to a product, sector acknowledgment helps a product define its relevance. Look at body sprays like Lever Fabergé's Impulse, which all use the same tall, thin can. Some time ago, Lippa Pearce was briefed on a range of men's toiletries. During the design process, we were involved in the selection of the structural packaging for the range. One thing was a given—the shape of the body spray: Lynx, a Lever Fabergé brand, had launched a body spray in a very distinctive domed, capped can and this shape became so established in men's minds with body sprays that our client had to adopt the same shape.

Abusing sector cues can also lead to the appropriation of a brand's visual equity, so potently demonstrated by "me-toos" and "copy cat" designs. Imagine our relief when we were briefed by Waitrose to design their oven fries and were explicitly asked not to copy the orange used so predominantly in McCains, the UK brand leader's, packaging. I am not sure other retailers would have been so confident of their own "handwriting", to use Waitrose's phrase about their design aesthetic, to not exploit such a strong cue.

Right: Leg work
In the hosiery sector, it's clear that showing the product being worn is important to consumers. Each of these packs adheres to this 'rule' but still manages to be distinctive. Designed, from top, by Turner Duckworth, Lewis Moberly, Turner Duckworth, and Dew Gibbons.

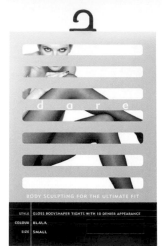

dare

BODY SCULPTING FOR THE ULTIMATE FIT

STYLE	GLOSS BODYSHAPER TIGHTS WITH 10 DENIER APPEARANCE
COLOUR	BLACK
SIZE	SMALL

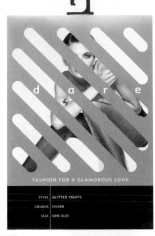

dare

FASHION FOR A GLAMOROUS LOOK

STYLE	GLITTER TIGHTS
COLOUR	SILVER
SIZE	ONE SIZE

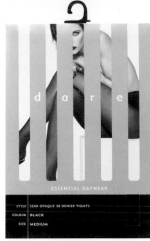

dare

ESSENTIAL DAYWEAR

STYLE	SEMI-OPAQUE 30 DENIER TIGHTS
COLOUR	BLACK
SIZE	MEDIUM

Boots

SHEER TIGHTS

15 DENIER

Boots

SHEER TIGHTS

Boots

SHEER TIGHTS WITH LYCRA

15 DENIER

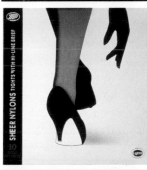

Boots

SHEER NYLONS TIGHTS WITH HI-LINE BRIEF

10

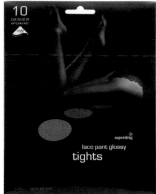

10 DENIER APPEARANCE

superdrug

lace pant glossy
tights

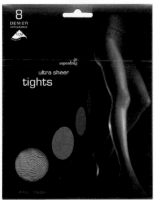

8 DENIER APPEARANCE

superdrug

ultra sheer
tights

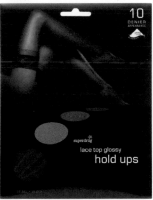

10 DENIER APPEARANCE

superdrug

lace top glossy
hold ups

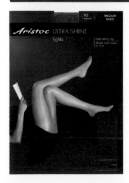

Aristoc ULTRA SHINE tights

10 denier MEDIUM NUDE

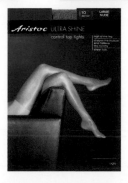

Aristoc ULTRA SHINE control top tights

10 denier LARGE NUDE

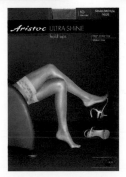

Aristoc ULTRA SHINE hold ups

10 denier SMALL/MEDIUM NUDE

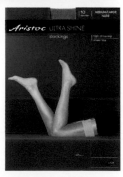

Aristoc ULTRA SHINE stockings

10 denier MEDIUM/LARGE NUDE

Being different for the sake of difference is a risky strategy and in Waitrose's case our design carried enough other visual elements to root it in the category. Product differentiation is a factor this book continually returns to but it cannot be achieved at the expense of everything else. There have been some notable successes of late (see William Murray Hamms's Hovis designs on page 16), where a new approach has been adopted to a category, but equally there have been some failures where the new was just too shocking. As Jonathan Ive, Head of Design at Apple Computers says: "It's very easy to be different, but very difficult to be better".

Style infusions
In contrast to the hosiery sector, the speciality teas sector seemingly has no defining characteristic beyond a degree of sophistication and "exoticness" employed in its packaging design. Designed, clockwise from left to right, by Mayday, Sandstrom Design, and Pentagram.

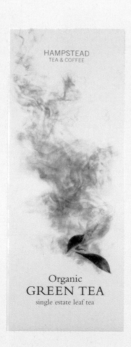

HAMPSTEAD
TEA & COFFEE

Organic
GREEN TEA
single estate leaf tea

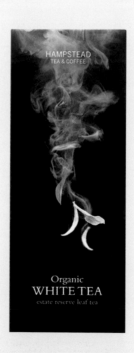

HAMPSTEAD
TEA & COFFEE

Organic
WHITE TEA
estate reserve leaf tea

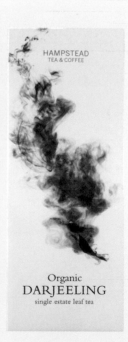

HAMPSTEAD
TEA & COFFEE

Organic
DARJEELING
single estate leaf tea

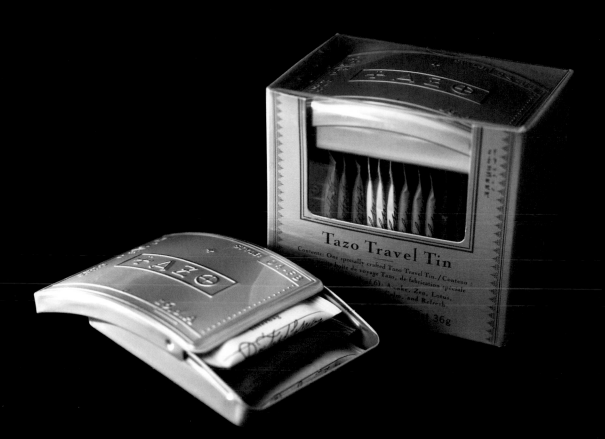

Tazo Travel Tin

Contents: One specially crafted Tazo Travel Tin./Contenu : boîte de voyage Tazo, de fabrication spéciale ... (6). A...ke, Zen, Lotus, ... Calm, and Refresh, ... 36g

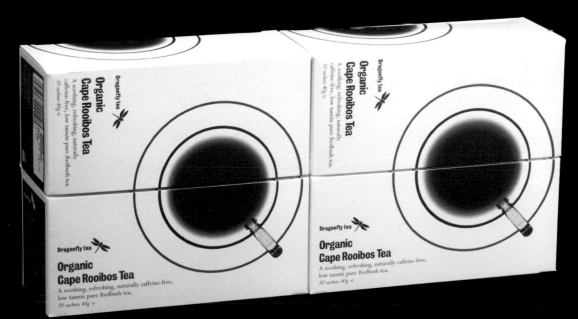

Dragonfly tea

Organic Cape Rooibos Tea

A soothing, refreshing, naturally caffeine-free, low tannin pure Redbush tea.
20 sachets 40g e

Market positioning

Once upon a time, there were shoppers, and then there were consumers. Now the concept of the market is so strong that even public sector services like hospitals refer to patients as customers. The consumer may be king or queen, but they are certainly not cut from the same cloth. People have infinitely different needs and desires.

Partly these needs and desires are fuelled by the sheer abundance in our lives. As Kunde says: "Today, the western world is over-supplied. There is an over-abundance of everything. There are too many shops, too many advertising channels, too many TV channels, hamburgers, cars, clothes, and just about anything else you'd care to think of. We live in an age of excess." Having so much choice means that consumers can now define themselves, their individualism personified by the products they buy, the brands they display.

People's needs are partly affected by socio-demographic factors. People talk of the "grey dollar" to describe the purchasing power of older, retired individuals, and different groups are given acronyms, like "DINKYs" (double income no kids yet) or names like "empty nesters" (families where the children have left home). People's desires are also affected by their lifestyles. Marketeers in the UK refer to the "pink pound" when talking about gay consumers.

Right: Poetic cheese
When Gedi launched its goats' cheeses onto the UK market, it wanted consumers to consider them the very best quality—easily as good as the finest French cheeses. As a consequence, the packaging design features several devices (such as lines from Coleridge's *Kubla Khan* and a repeat pattern of baby goats printed as a gloss varnish), that position the product at the top end of the market. Designed by Lippa Pearce.

GEDI

The full Arcadian range consists of:

1 **Natural**
2 **Fine Herbs**
3 **Garlic**
4 **Black Pepper**
5 **Red & Green Pepper**

Ingredients

White appearance
Dark green appearance
Green appearance
Dark appearance
Red & green appearance

Young fresh cheese with a mild tangy flavour.
Delicate seed plant relish.
Light garlicky taste.
With a hint of spicy piquant flavour.
A pinch of sweetish flavour.

Pure goat's milk, sea salt,
vegetarian rennet.
No artificial ingredients

Full fat soft cheese made from pasteurised
goat's milk

Keep refrigerated in cling film

To intensify Arcadian's creamy flavour and texture always remove it from refrigerator one hour befo
fruity young red wine is the natural accompaniment to Arcadian. This combination makes an indulge
climax to a special meal.

Gedi Enterprises Ltd, Plumridge Farm, Stagg Hill, Barnet, Herts EN4 0PX Telephone 081 449

GEDI

For he an Har…

FULL FAT SOFT C… E MADE
FROM PA…TEURIZED …TS MILK

Arcadian

110g

Produce of the UK

Consumer individuality has resulted in the development of niche markets and the concomitant development of interesting and picturesque descriptions of these markets. For example, "early adopters", particularly prevalent in technology markets like mobile phones and computer equipment, are those likely to take up new technologies prior to mass-market presence. Each niche market has its own idiosyncrasies and understanding these is fundamental to the design process.

In fact, whether the target market is mass or niche, understanding it lies at the very essence of good design as it enables you to position the product. It's impossible to design packaging that is relevant without understanding who will use it. It's difficult to create a design that will have a resonance with the target market without understanding their needs and desires. You must understand what emotional and rational triggers the target market will respond to if you are to create packaging that communicates a powerful proposition. Consumer selection is influenced by relevance, and relevance is driven by market positioning.

Achieving an understanding of the target market means you have to put yourselves in their shoes. Research helps, as does visiting stores and watching shoppers. Talking to people

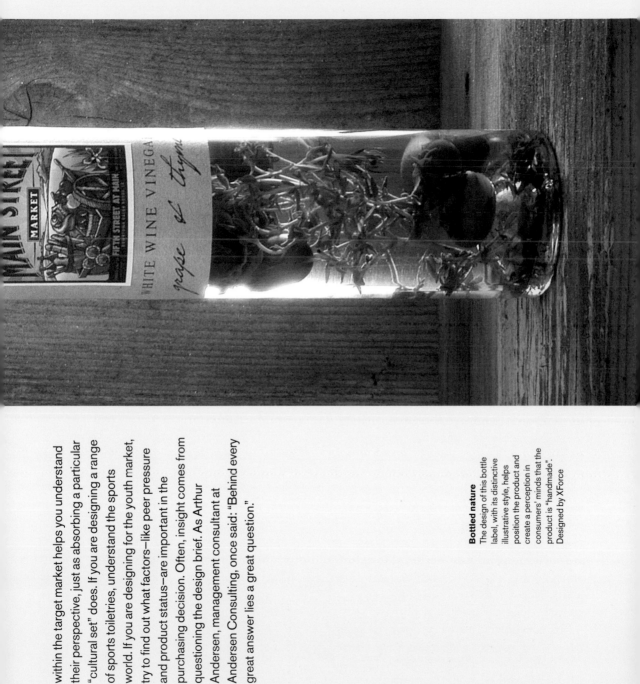

within the target market helps you understand their perspective, just as absorbing a particular "cultural set" does. If you are designing a range of sports toiletries, understand the sports world. If you are designing for the youth market, try to find out what factors—like peer pressure and product status—are important in the purchasing decision. Often, insight comes from questioning the design brief. As Arthur Andersen, management consultant at Andersen Consulting, once said: "Behind every great answer lies a great question."

Bottled nature
The design of this bottle label, with its distinctive illustrative style, helps position the product and create a perception in consumers' minds that the product is "handmade". Designed by XForce

Environmental considerations

I spoke at a conference with one of my retail clients, and during the questions section he was challenged on his company's attitude to the environment. One questioner even went so far as to inquire why his company did not provide recycling facilities outside his stores so that customers could throw their packaging away immediately or bring it back for disposal.

Environmental concerns affect manufacturers and retailers alike. For many, they now form part of their corporate social responsibilities, featured in annual reports and policy documents alike. For others, in countries like Germany, strict laws govern environmental considerations. In 1996, the German government introduced a law holding manufacturers responsible for secondary packaging such as cartons.

These considerations are by no means simple because the whole environmental issue is colored by factors like sustainability, recycling, and recyclable materials. According to an article in *Communication Arts* (September/October 1999), packaging makes up one third of the waste of the United States, and one quarter of US landfills are made up of unrecycled plastic containers.

Sustainability impacts design decisions because it focuses the attention of all parties on the issues relating to a product's manufacture, its raw materials, transportation, retailing, usage, and disposal. It concentrates on factors like energy and materials usage, fuel costs for transportation, packaging production processes and by-products, disposal capability, and environmental impact.

Recycling affects packaging design because it influences the choice of materials. Some plastics can be recycled—like Polyethylene Terephthalate (PET)—while others—like Polystyrene—are

Social fiber
The Costa Rica Natural Paper Company's own natural-fiber stock was used for the packaging of these cigars. By recycling industrial quantities of tobacco leaves, the company saves trees and cuts down on landfill-clogging, river polluting waste. The packaging thus becomes emblematic of the company's environmental philosophy. Designed by The Greteman Group.

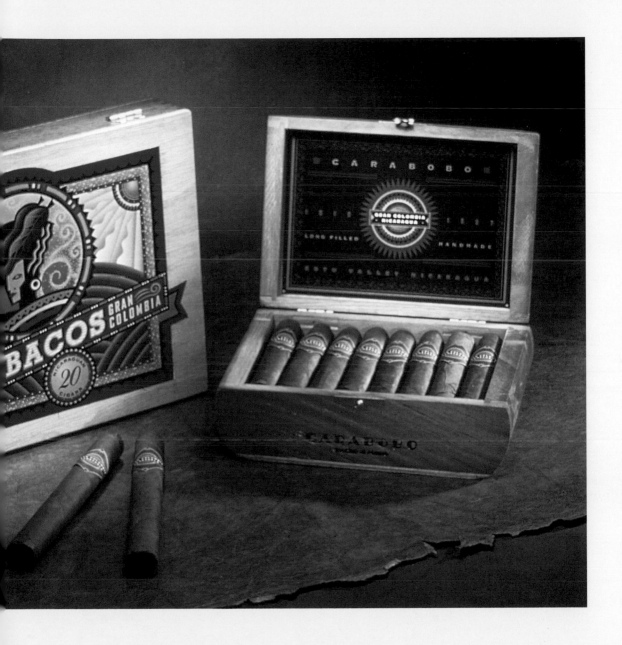

seldom recycled. In turn, recyclability is affected by packaging that uses more than one substrate—like a bottle and cap—and by the provision of facilities to sort and dispose of packaging for recycling.

Choosing recyclable substrates is approaching the issue from the other end and is often favorable: using a recycled substrate is an easier way to demonstrate one's environmental credentials than using a substrate consumers can't recognize as good or bad for the environment. In the past, packaging specifiers were restricted in their choice of good-quality carton boards, for example, but manufacturers have been responding to demand and now produce stocks with the right finish for most types of product.

The role of packaging designers in the great environmental debate will always be influenced by the client, by cost, by individual responsibility, and ultimately by the brief, because the brief encapsulates the commercial imperative behind any design project. Designers can play their part by being cognizant of the issues and trying to influence their clients' choice of materials.

Environmental icons
A selection of the environmental icons employed on packaging.

Legislation

There are laws governing the display of certain types of information on packaging—such as weights and measures—and there are bodies such as the USA's Food and Drug Administration, and the UK's Medicines and Healthcare Products Regulatory Agency, that regulate what manufacturers say about certain types of drugs. There are also laws governing the use of language on packaging. In Canada, for example, products have to feature both English and French to satisfy the needs of its "twin nations". In addition, there is consumer protection legislation that imposes rules on manufacturers to display health warnings and information, such as country of origin. The cigarette packaging design opposite is a great example of this type of legislation.

Any designer worth his or her salt will know these laws, and will have the "protection" of a client's Legal Department to check a design's legality. It is still important to keep abreast of changes in the law, like those being introduced by Australia's Therapeutic Goods Administration, or new government initiatives, like the UK's Department of Health's best practice guidance on medicine labelling and packaging issued in March 2003.

Designers also have to be aware of the copyright laws that protect the intellectual property rights of companies and individuals. In its publication *A Guide to Brand Protection*, the British Brands Group writes: "Brands are your company's prime asset and the foundation of the business. They are the source of revenue and profitability and the key to future prosperity… As brands are your company's most important assets, damage to them damages your company's revenue, reputation and profitability." Every nation has laws

protecting intellectual property right holders. The rights associated with a brand encompass its trademarks—such as names or words, letters and numbers, slogans, logotypes, images, colors, packaging shapes, sounds and smells—its copyrights, designs, patents, and trade secrets. Woe betide any designer who infringes a brand's rights—for example, by making a brand look like an existing brand—because he or she will incur the full force of the law.

Designers are also governed by the rules and conventions imposed by their clients. The most obvious example of a "rule" is the brand guideline that controls the proper and consistent use of a brand's visual identity, but companies also have other self-imposed conventions. One of my clients, The Boots Company, insists that the minimum type size allowed on healthcare packaging is six point, in recognition of the poorer eyesight of some of its older customers.

SURGEON GENERAL'S WARNING: Quitting Smoking Now Greatly Reduces Serious Risks to Your Health

Explicit labels
From October 2003, after new legislation in the UK, health warnings now occupy 30 percent of the front and 40 percent of the back of cigarette packaging (right); while in the US, warnings are quite restrained in comparison (left).

Tar 11 mg

Nicotine
0.8 mg

Carbon
monoxide
11 mg

Smoking
kills

Anatomy

All packaging design projects start with the brief, and the success of a project can often relate to the quality of the initial briefing. When I first started in advertising at Ogilvy & Mather, in 1985, I attended an induction where I heard Norman Berry, executive creative director, express the sentiment: "Give me the creative freedom of a tightly defined brief". John Simmons, in his book *The Invisible Grail* (2003) quotes Douglas R. Hofstadter, scientist and polymath: "I suspect that the welcoming of constraints is, at bottom, the deepest secret of creativity". David Gentleman echoes this in *Artworks* (2002), where the Chinese proverb, "Every kite needs the string," describes the creative process borne of constraint.

All designers need to know the parameters within which they must work—a good brief provides these. The more one knows about the brand's proposition, its values, and personality traits, the better. The greater one's awareness of the target market and its rational and emotional needs, the greater one's ability to design a solution that strikes a resonance with the consumers. The more one knows about the competitive set and retail environment, the more one can design a truly differentiated solution.

Good clients provide tight briefs. Bad clients often provide the reverse and use the design process to try and arrive at a design solution that they think will work. As a result, the design process becomes a drawn-out affair. A good design brief "anchors" the designers to a set of key objectives and provides a process for evaluating the proposed design solution. In doing this, it also eliminates the one thing that is a bugbear in all designers' lives—subjectivity. Having sat in a presentation and had a design rejected because the client thought the colors

chosen reminded him of the Union Jack flag, I know how frustrating subjectivity can be. Good design will always display its true worth but a tight brief supports the designer's rationale for all of the decisions he or she has made. Good designers make these decisions in response to the brief, using their skills and experience to, in Gentleman's words: "Consider, assess, select, arrange, emphasize, simplify, order, and adapt to circumstance and control." These decisions form the basis of this section.

Design is a composite of the designer's vision and the expression of that vision using some or all of the elements of design. Packaging design's elements divide into structural and surface graphics; then subdivide into form and function, materials and finishes, branding and typography, imagery and color. In recognition of the two components—structural design and surface graphics—the Anatomy section is divided in two. Within each subsection, samples of work have been chosen which illustrate how different designers have practiced their craft to fulfil a brief or address a specific objective. In many respects, this division is artificial because structural design and surface graphics can never be viewed in isolation (it's impossible to design a label without knowing the size and shape of the package). However, the book's structure has been dictated by a desire to show the multiplicity of design elements at a designer's disposal—subject to budget and time constraints—and the application of these elements in a coherent, thoughtful manner.

"GIVE ME THE CREATIVE FREEDOM OF A TIGHTLY DEFINED BRIEF"

NORMAN BERRY

Structural design

Structural design encompasses a huge array of different packaging types. Visit any supermarket or superstore today, and the sheer variety of packaging formats is extraordinary. In some instances, this variety derives from the multiplicity of options available for one form of packaging such as bottles, which come in a large and diverse range of sizes, shapes, finishes, and colors. In other cases, this variety just derives from the range of packaging solutions that have been invented to transport, package, store, protect, display, and brand a product.

Structural design is practiced by specialist designers working within a large design consultancy, where their discipline is one part of an integrated service offering; by designers working within the three-dimensional product design field: and by designers employed by structural packaging manufacturers, like carton producers. In the latter case, design is often seen as an "added-value" service, created to offer clients bespoke solutions to their individual needs.

All structural designers essentially start from the same point—a set of tasks and objectives encapsulated in a brief. Their job is to understand the client's requirements and create a solution that answers all of the issues—issues such as transportation and warehousing, product handling and storage, display and merchandising, material selection and environmental considerations, filling or packing, and raw materials, production, and transportation costs.

Many of the factors affecting a structural design brief are very complex and require an intimate knowledge of materials, behavior and tolerances, production processes and packaging technologies. In part, this knowledge ensures due diligence, often vital when packaging products which can be potentially harmful (such as solvents) or packaging products (such as medicines) which can be sensitive to environmental factors like ultra-violet light. It also ensures that, when designers are asked to create new and innovative formats, they understand what is and isn't possible.

In some cases, structural designers answer to two types of clients, those responsible for the "technical" aspects of a particular piece of packaging, often known as "packaging technologists", and those responsible for the "brand" aspects of a piece of packaging—the brand and product managers. In such cases the designer's tasks is to balance the concerns of both to produce packaging that will ultimately address the needs of the end user, the consumer. Packaging technologists are invariably concerned with the production and logistical suitability of a piece of packaging, while a brand manager may well be trying to "push the envelope" to achieve maximum brand impact and differentiation. The twin goals don't have to be mutually exclusive, but can lead to some interesting discussions.

I started by addressing the sheer scale of packaging available today, but to illustrate all of the different types would probably require a set of books rather than one. Therefore, I have chosen just a few packaging formats to illustrate structural designers' considerations and approaches.

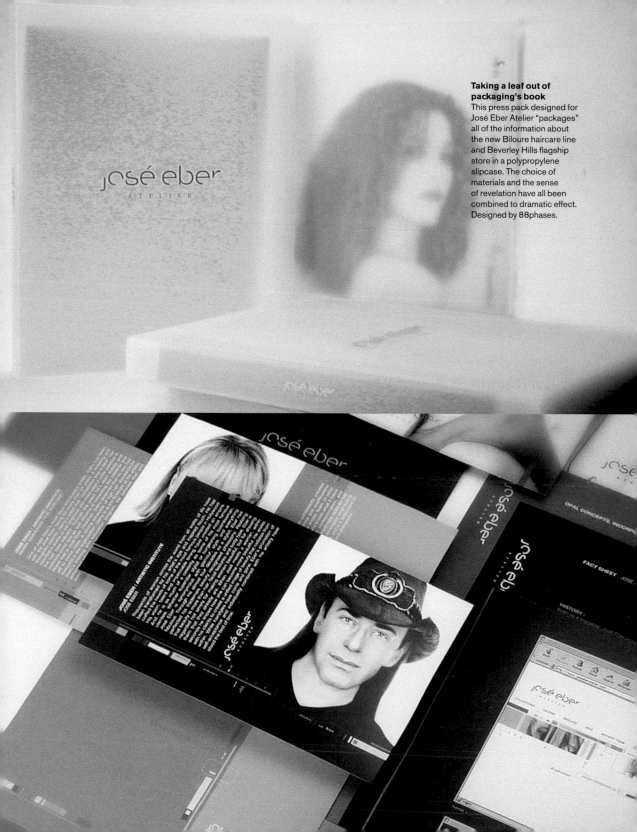

Taking a leaf out of packaging's book
This press pack designed for José Eber Atelier "packages" all of the information about the new Biloure haircare line and Beverley Hills flagship store in a polypropylene slipcase. The choice of materials and the sense of revelation have all been combined to dramatic effect. Designed by 88phases.

Cartons

Cartons are one of the most common forms of packaging and are employed to package products as diverse as frozen food and cosmetics, electrical goods and medicines, and confectionery and household goods. Their design is influenced by the packaging's functional size, shape, and strength requirements, and by marketing considerations such as brand profile, product display, as well as feature and benefit communication.

With some products, like dry foodstuffs, the packaging may be important for storing the product, while for others, like frozen foods or personal care products, the packaging may be disposed of as soon as its used. For products like electrical goods, the size of the packaging may be determined by the need to protect the product. With others, the size may be determined by the secondary packaging, such as a bottle, inside. Size may also be determined by the inner packaging, such as a vacuum-formed tray, which holds the product in position to better protect or display it.

A carton's shape may similarly be influenced by the product it holds or by a desire to make it eye-catching on-shelf. Look at an average display of Easter eggs and you see that product display plays a large part in the shape and structure of the packaging, to the extent that the product often seems disproportionately small compared to its packaging.

Cartons are made from a variety of boards. Solid, bleached board is typically used for products like cosmetics, pharmaceuticals, and frozen foods. Folding boxboard is often used for food packaging, while white-lined chipboard is usually employed for products where it doesn't matter that the gray middle layers of the board show. Unlined chipboard is often used

Right: Smell the graphics
These incense sticks, given away at the opening of a Thai fast-food noodle chain, feature a graphic on the side of the carton which echoes the shape of noodles. The inclusion of a window means that the incense sticks become a witty part of this graphic device. Designed by Duffy.

Below: Driven by brand
Yakima's car roof rack cartons are made of recyclable packaging materials and inks that contain a high percentage of post consumer waste, to communicate the company's environmental responsibilities. Robust in design to protect the contents, the packaging is engineered to both reinforce the quality of the products and reflect Yakima's simple, utilitarian design aesthetic. Designed by Duffy.

for packaging such as shoe boxes, where it is covered or decorated. Corrugated boards are usually chosen for outer transportation and warehouse packaging, where its structure makes it stronger and more robust.

Some types of carton board are chosen because they perform better, or convey the right quality cues. They are also selected because they will print better using high-speed litho or gravure processes. They are also more suitable for high quality cutting and creasing, vital in many of the automated packaging and handling systems employed today.

Carton boards are also treated in different ways, dependent upon the product they will package. Cartons which need to be moisture-resistant or heat sealable can be coated with Polyethylene or wax. Alternatively, boards can be laminated with aluminum foil to create a moisture-resistant barrier.

Alternatively, carton board can be treated to improve its look or feel. Clay coating gives a board a very high-gloss finish, reduces ink consumption, and improves the quality of its printing. Similarly, cartons can be treated to add to the polysensorial and visual experience (see page 154).

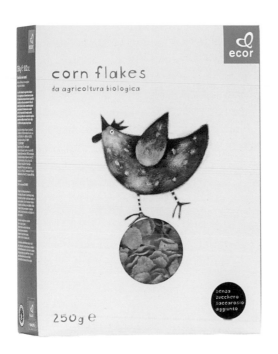

Left: Bags of quality
Everything about the look,
construction, choice of
materials, finishing, and feel
of the boxes produced for
Jasper Conran's range
communicate the value
and quality of the products
themselves. Designed by
Lewis Moberly.

Right: Perfectly illustrated
Ecor's range of breakfast
cereals—featuring bright,
whimsical illustrations by the
Italian illustrator Alessandra
Cimatoribus—combine
individual product display
with a device guaranteed
to be seen as funny and
involving by the products'
target market, children.
Designed by Metalli Lindberg.

Bottles

According to the UK Institute of Packaging, glass was first discovered by the Mesopotamians and the first glass vessels date back to 1,500 BC. Over the centuries, as glass manufacturing became more and more sophisticated, it became the standard material for bottles. A composite of sand, lime, soda, and alumina, glass is capable of being moulded into a huge range of shapes and sizes.

In the last century, the supremacy of glass as the material of choice for bottles has been challenged with the invention of new plastics and production methods, such as extrusion blow and injection moulding. These thermoplastics include Low-density Polyethylene (LDPE), High-density Polyethylene (HDPE), Linear Low-density Polyethylene (LLDPE), Polypropylene (PP), Polyvinylchloride (PVC), and Polyester (PET). Each one has different qualities and is usually employed for different types of packaging. For example, HDPE, which is a more rigid, opaque plastic with a hard finish, is usually used for bottles holding household chemicals such as bleach. PET is often used for drinks bottles, having a transparency and clarity that rivals glass.

Designers' choice of glass or plastic is influenced by several factors. In some cases, glass must be used. Pharmaceutical bottles need to be cleaned and sterilized, using steam or dry heat, and plastics would distort if subjected to this treatment. Some products like beer need to be pasteurized, so also require glass, as do preserved fruit and vegetables. Some products, like peanut butter, need to be filled hot, because in their cold state they are too solid.

In other cases, cost will be a primary determinant, which is where plastics do and don't come into their own. With fast-moving consumer goods keeping the cost of packaging down, it is extremely important in price-sensitive areas where retailer margins and competitive activity can affect the recommended retail price. In other areas, like fine spirits, plastic simply does not convey the same quality as glass, taking the product down-market in consumers' eyes.

Product safety is also vitally important in material selection. In many cases, the fragility of the glass makes it unsuitable for bath or shower products, just as it does for some baby products.

Below:
Sculptured identity
This specially designed bottle for O$^+$ includes a sculptured neck that reflects, and therefore reinforces, the brand identity. Bottle and graphics combine to create an inimitable look. Designed by Blackburns.

Right: Pedigree design
The quality and pedigree of Dewar's scotch is conveyed by the unique design of Dewar's bottle. Its sculptural form and distinctive look turn it into an item to be proudly displayed in one's drinks cabinet. Designed by Tutssels Enterprise IG.

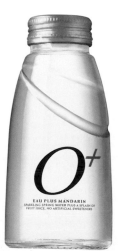

In addition to the selection of materials designers can influence consumers' purchasing decisions by fully exploiting both the shape of a bottle or jar and by using the full panoply of colors at their disposal. Shape and color can influence consumers' perceptions of a product's quality, desirability, provenance, relevance, and usage. Shape, as in the case of We Live Like This (right), can also contribute to the communication of a brand's difference. In some areas like perfumes and fragrances, bottle shape is the defining element of the brand—the very thing that turns a colored, fragranced liquid into a thing of value and cachet.

Below left: Two hundred years of history
To celebrate Jim Beam's 200th anniversary Duffy designed a new decanter for Jim Beam's special celebratory bourbon. The bottle is distinctive not only for its shape but its swing-top.

Below right: Cream of society
The distinctive blue of Harveys Bristol Cream derives from Bristol Blue glass, unique to the City of Bristol since the late 18th century. Designed by Blackburns.

Hole in one
The bottle's hole was originally created so that consumers could hang the products up in the shower. Mostly by default it has also given the brand a differentiator and created a look which is very bathroom ornament as well. Designed by Natural Products Ltd.

we live like this©

strangefruit
body lotion
lait corporel
250 ml ℮ 8.8 oz

we live like this©

strangefruit
pure soap | savon
125g ℮

Tubes

Tubes invariably come in two types: metal and plastic. In the past, metal tubes were made of tin, lead, and tin–lead alloys, but nowadays the usual metal used is aluminum. While the flow-line production process for metal tubes governs their shape, size, and the relative conservatism of their design, new technological advances in plastic tubes has seen the development of new shapes, including contoured ends.

Tubes illustrate one area of packaging design where designers have to make the most of the restrictions of the format, whether in the design of the tube itself, or the way graphics are applied. The design of the physical packaging may amount to no more than designing a new cap, or selecting a new color or finish. In the case of the graphics, these may be determined by the limitations of the printing process.

Metal tubes use a process called Dry Offset Letterpress where the design is transferred color-by-color onto a central blanket cylinder and then rolled onto the can in one pass. As a result, this process does not replicate half-tones well. Plastic tubes are printed in two ways: laminate tubes are printed flat, using a litho process, and then formed after printing. This process allows four-color process and specials as well as finishing, like cold foil blocking. Also, additional stations can be added to the print machines so that processes like silk-screening of flat, opaque colors, can be added. Co-extruded tubes are much more limited in what they can achieve because the tubes are formed and printed at the same time, like aluminum cans. Understanding how a tube will be manufactured will therefore have an effect on the complexity and type of design chosen.

Right: Hippie chic
To my mind, this tube is a perfect marriage of physical shape and graphics. It's certainly eye-catching and a perfect encapsulation of the brand's personality. What's more, the tube's cap (both its design and color) plays a major part in creating the overall look. Designed by Christophe Linconnu.

Overleaf, from left: Haircare bunch
Four tubes utilizing different shapes and graphics. Garnier Synergie Aqua Wash is printed directly onto the Polyethylene, while both Charles Worthington and Umberto Giannini employ applied labels. While Charles Worthington opts for a striking, typographic solution, Umberto Giannini takes advantage of the label's superior print finish to achieve a highly sophisticated look. In contrast, Zirh elects to exploit the metal tube's "natural state" and letterpress printing process to achieve a modern, efficacious look. Designed, from left to right, by Garnier Synergie, Kato Shaw, Umberto Giannini Hair Cosmetics Company Design Team, and Heads Inc.

ESCADA
IBIZA HIPPIE

Bath and Shower Gel
Gel de Bain Moussant
5.1 FL OZ. / 150 ML e

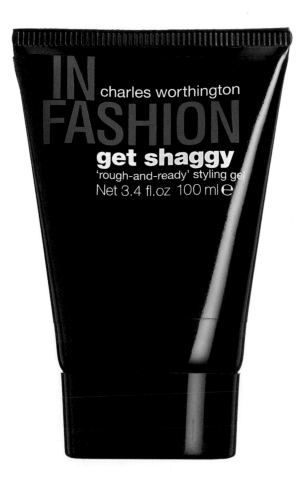

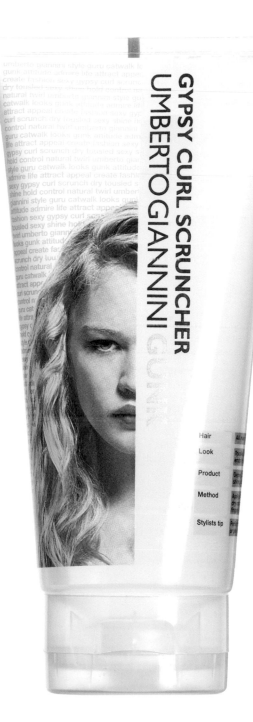

GYPSY CURL SCRUNCHER
UMBERTO GIANNINI GUNK

Hair

Look

Product

Method

Stylists tip

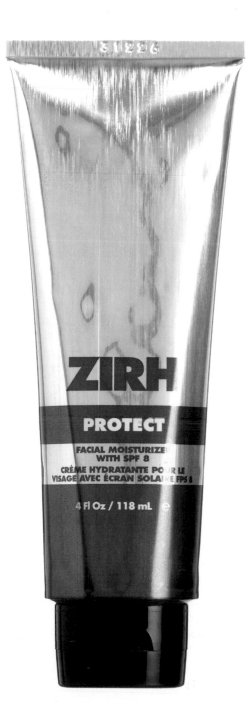

ZIRH

PROTECT

FACIAL MOISTURIZER
WITH SPF 8

CRÈME HYDRATANTE POUR LE
VISAGE AVEC ÉCRAN SOLAIRE FPS 8

4 Fl Oz / 118 mL

Cans

Cans were developed and first used during the Napoleonic Wars (1803-15), and since then can manufacture has become a massive industry. In 2001, the European market for drinks cans reached 38 billion and it is still growing, spurred by new markets like Eastern Europe where tin usage has grown from 280 million in 1995, to 2.4 billion in 2001.

Cans are used widely for food and beverages, and are made from a variety of materials. Tinplate is made of thin, mild-steel which is given a thin coating of tin on each surface. The depth of the coating can be altered so that cans containing products which are highly corrosive can have a thicker inner layer to protect against chemical attack by the product.

Backplate is tinplate without the tin. Because it can corrode very easily, backplate has limited applications, but is often used for products like oils and greases. Tin-free steel is mild-steel sheet covered with a coating other than tin. It was developed to counter the increasing cost of tin and usually employs a chromium-based compound. However, this format does have limitations, as it is not soldered or welded easily.

Aluminum is commonly used for certain types of products such as drinks. The material is protected from corrosion by the thin layer of oxide that forms on the metal when it is exposed to the air. Like tin-free steel, aluminum cannot be easily soldered or welded and is mostly used for drawn cans.

Cans are manufactured using a variety of methods. Three-piece, seamed cans are created using three pieces of metal, formed into the desired shape, then welded or soldered together. Usually, they are supplied open to the product manufacturer, so that the cans can be filled and the separate lids attached.

Two-piece cans have been developed to try to reduce the amount of materials used, the most significant cost in any can. They are produced using steel or aluminum, using two methods: drawn and wall-ironed two-piece cans (DWI) and drawn and re-drawn two-piece cans (DRD). DWI is usually only used for carbonated drinks because the side walls of the can become very thin during the manufacturing process. The gases used in carbonated drinks provide internal pressure that supports the can. As a result, when the can is empty it can be squashed easily.

Right: Two-bit composition
A typical example of a two-piece seamless aluminum can with ring-pull opening. The strong graphics illustrate well the designer's focus on the front "selling" face. Designed by Mutter.

Left: Solid steel
Made of recycled steel, this can is a good example of its type. Robust, stable, and with a good-sized opening it performs its function well. Designed by Jones Knowles Ritchie.

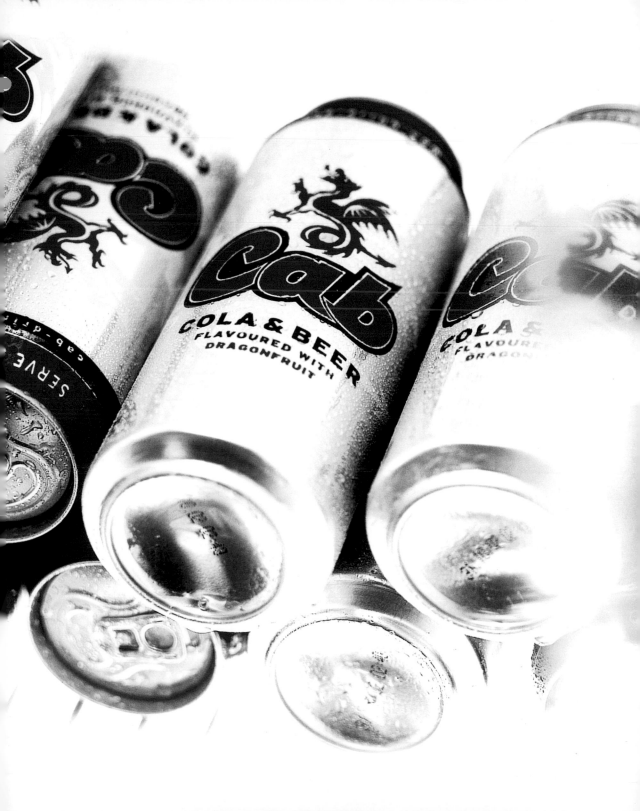

DRD's manufacturing process enables the metal to be printed in a flat sheet before forming. However, because of the process involved, the design needs to be distorted so that when the can is formed the correct image will appear on the finished can.

Certain cans, like aluminum aerosols, use an impact extrusion process. During the manufacturing process, the top is formed to give the right shape and dimensions needed to give a good seal to the valve that will be applied. The great virtue of DWI, DRD, and extruded cans is that they have no side seams and are "cleaner" in appearance, allowing a design to feature all the way around the tin.

For a designer working with cans, it is obviously important to understand the manufacturing process, and the impact it will have on both the design and its reproduction. On a very simplistic level, it is also important to understand how the profile of the can, the visible on-shelf area, will affect how the design is applied. Some tins, like those containing spray paints, are also displayed in gravity-fed dispensers—it is vital to understand how much of the can is visible to the consumer and design accordingly.

The size, shape, and finishing of cans can have a huge impact on consumers' perceptions of a product, and designers have a role to play in selecting formats that support the range line-up and brand proposition. In 1998, Sapporo, one of Japan's oldest beer brands, launched a draft beer in a distinctive-shaped can with a ring-pull that removed the whole lid. The can became, in an instant, a drinking vessel. The novelty of the format made it a success, and made Sapporo look like a contemporary young man's brand.

Can manufacturers have also been focusing on new product developments, not only to find ways of manufacturing cans more cheaply and efficiently, but to challenge consumers' perceptions of the format. In the UK, Sainsbury's successfully piloted a square can for its own-brand tomato soup. Other manufacturers are also developing new finishes and formats. The drinks brand Baileys added a sparkle to the coating on its Christmas cans while Nescafe launched a self-heating can. ICI has introduced a new, plastic-coated internal ring to prevent corrosion on the lid and ring area of its Once paint cans.

Right: Object of desire
Considerable time has been invested in making products in US brand Benefit's bathroom range desirable accessories, as well as functional items. The metallic finish and finely finished lid add to consumers' perceptions of the product. Designed by Benefit's Company Design Team.

Tubs and jars

Tubs and jars are used as packaging in every sector: from medicines to foodstuffs, DIY to homecare products. Tubs and jars are the things that we receive our prescription medicines in, the things we spoon our jams out of, and they are also the things we buy mascara or foundation in.

The range of shapes and sizes that tubs and jars come in is huge, as is the spectrum of closures—from tamperproof to child-resistant, metal lids to plastic caps. It's an area of packaging where manufacturers constantly feed brand owners with new ways to present their products, to position their brands, and differentiate themselves from the competition. As one manufacturer states in its advertising: "Inspiration, design excellence, and business expertise are directed to one goal: to provide cosmetic packaging inspired by trends, ruled by taste, and tailored to your brand."

The design and selection of tubs and jars is influenced by factors like price, product format and stability, range line-up, market sector, and product usage. Likewise, the construction of these formats is affected by a large number of factors that may determine whether a plastic substrate or glass is used, or whether finishes like glazing, metallizing, varnishing, ionisation, or lacquering are applied.

It is also an area where differences are measured in large and small increments. A tub may have a new cap, or overcap, developed for it with a slightly changed profile to reflect a new season's look. Conversely, a completely new tub or top may be developed, quite distinct from anything else. Whether large or small, these differences affect consumers' perceptions of products' relevance, usability, convenience, and lifestyle compatibility.

Right: Stacks of style
These eye shadows fit snugly together, making them easy to keep as one. They illustrate the care and attention that goes into the selection of formats, sizes, materials, and finishes for cosmetic products. Designed by Michael Nash Associates.

Below: Vitamin boost
The innovative new tub shapes—which clearly differentiate Superdrug vitamins from other competitive products—have been designed to help the elderly open "unopenable" childproof lids, and enable consumers to hang up the products in visible spots around the house. Designed by Turner Duckworth.

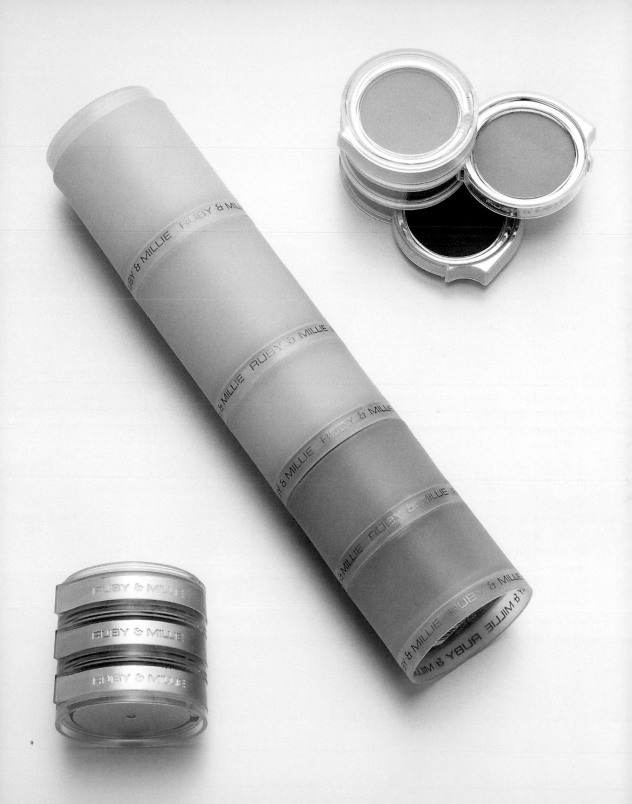

Continental preserve
To make these jams look different on shelf, reinforce their continental origins, and suggest the quality of the produce, Waitrose chose these jars with their distinctive handles and black lids. Designed by Lippa Pearce.

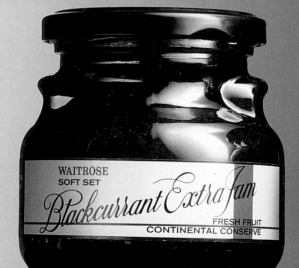

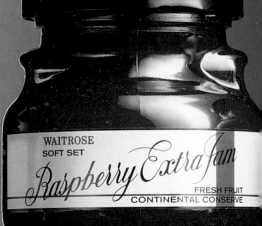

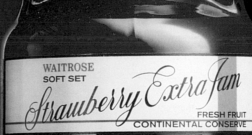

Multi-packs

In some areas, like dairy, tinned produce, and drinks, products are sold in multi-packs, either as handy-multiples or promotional packs. This may mean that individual products are grouped together and packaged in a wrapper or carton, or products are specifically manufactured as a multiple. Each affords new design challenges and opportunities.

Products like multi-packs of yogurts are either packaged in a carton board sleeve or the cartons themselves are moulded as sets of four, six, and so on, with a sealed membrane extending across all of the cartons. The greater display area afforded by the larger membrane gives designers more opportunities for brand and product communication—and greater impact in the chiller, provided the "rules" of individual product identification are obeyed, so that consumers know which flavor is in which carton.

Products like drinks are multi-packed using wrappers, cartons, and trays, and these formats normally provide designers with an opportunity to create a larger brand profile than the individual drink allows. It also means that other product "stories" can be told through words and pictures.

**Below and right:
Multiples options**
Two different approaches to packaging multiples of beer bottles, a carton and a card wrapper. Both designed by Wertmarke.

Character-building
Brewerkz is a Singapore-based microbrewery with an eclectic, professional clientele that likes to know about the beer it is drinking. The illustrations that feature on each of the different beer labels highlight the character of each beer, and are a distinctive feature of the brand's look. They also feature as a group on Brewerkz's six-pack, in a design that is conspicuous for its color palette and simplicity. Designed by Saatchi & Saatchi Singapore.

330ml
India Pale Ale
FULL-BODIED WITH GENEROUS HOPS, INDIA PALE ALE CONTAINS NO ADDED PRESERVATIVES. KEEP REFRIGERATED. SERVE AT 8'IN SINGAPORE, 13' IN THE UK. MAY CONTAIN SOME SEDIMENT. Bottled and Brewed by Brewerkz Restaurant and Microbrewery 30 Merchant Rd 01-05/06 Riverside Point S058282 www.brewerkz.com

fig 1 high gravity

6.5%ALC

330ml
Irish Red Ale
SWEET MALT WITH FRUITY UNDERTONES, IRISH RED ALE CONTAINS NO ADDED PRESERVATIVES. KEEP REFRIGERATED. SERVE AT 8'IN SINGAPORE, 13'IN IRELAND. MAY CONTAIN SOME SEDIMENT. Bottled and Brewed by Brewerkz Restaurant and Microbrewery 30 Merchant Rd 01-05/06 Riverside Point S058282 www.brewerkz.com

fig 1 complex

5.0%ALC

330ml

Brewerkz

4.5-6.5%^{ALC}

Clamshells and blister packs

Despite consumers' annoyance with them, some packaging formats thrive because of their protection, transportation, and display efficiencies. Few consumers like clamshells because they are so hard to open. Usually made of two moulded parts that are sealed together once the product has been inserted, a clamshell's rigidity, and sealed format normally drives the average person to distraction when he or she tries to open it.

Yet the clamshell's translucency is a very efficient means of displaying a product, unfettered by obstructions. It also means the product does not have to be photographed, as consumers can see the product itself. Moreover, clamshells' rigidity protects products in transit, and from the unwanted attentions of customers who illegally take things out of packaging. The inclusion of a euroslot at the top of clamshell packaging also makes the format very easy to display in a large range of shopping environments.

The challenge of the clamshell format to designers is to ensure that it performs its display and protection functions properly, while minimizing its materials usage and display footprint. The format normally reduces the area for graphics to a minimum, whether the graphics are printed onto the plastic of the clamshell or onto a card insert.

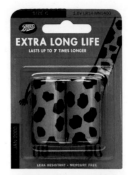

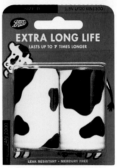

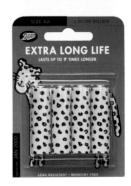

THE ORIGINAL LEATHERMAN®

SIDECLIP™

FEATURES

- Needlenose Pliers
- Regular Pliers
- Wire Cutters
- Hard Wire Cutters
- Clip Point Knife
- Serrated Knife
- Diamond-Coated File
- Cross-Cut File
- Wood Saw
- Scissors
- Extra Small Screwdriver
- Small Screwdriver
- Medium Screwdriver
- Large Screwdriver
- Phillips Screwdriver
- Can/Bottle Opener
- Wire Stripper
- Lanyard Attachment

PREMIUM
LEATHER
SHEATH
INCLUDED

BLADES FANNED OUT

THE DIFFERENCE:

Wave features access
to four locking blades
from the closed posi-
tion. Both knives
open with one hand.
Smooth, rounded
handles make it a
pleasure to hold.
Wave's got a bold

LEATHERMAN WAVE

ONE-HANDED LOCKING KNIFE BLADES

MADE IN U.S.A.

ONE TOOL. ...BLE THOUSAND USES.

Skin and blister packs share one thing in common. They both use paperboard card as the backing to the packaging. Other than that they are different. With skin packaging, the porous card has a heat-seal coating, which enables the plastic film—which is heated and then stretched over the product—to bond to the card. Often the card is perforated to help the flow of air. Because the product itself acts as the mold for the PVC or Ionomer film covering, the same packaging machine can be used for different shaped products within the same run.

Blister packaging is different in that the blister for the product is pre-formed using a mold. The blister is attached to the backing card using either heat-sealing or stapling. Sometimes the blister has turned edges to enable it to slide over the backing card, which in turn makes it easier for the consumer to take the product out.

In both skin and blister pack formats, the backing card is the primary design vehicle. Backing cards can be shaped using cutters, so this element of the design can be influenced while the surface graphic area will be determined by the space left after the blister containing the product and the euroslot have been taken into account.

Right: Transparent benefits
These clamshells are very "pure" examples of the form. Product display is maximized, while information is printed directly, and simply, onto the acetetate. Normally, clamshells involve some form of printed card insert, occupying all or part of the inner space. Designed by Sayuri Studio.

CDs

Compact discs are an interesting phenomena in packaging design terms, because designers not only start with a "prescribed" format, they also work with a slightly different purchase–usage ratio to other packaging. The prescription lies to a degree in the jewel case format. Most CDs now come packaged in a jewel case, whether the album has one or two discs: most CDs also now feature a booklet or tray insert, while some also feature a slipcase. The challenge for designers, given a free reign to look at the design of the whole package rather than just the graphics, is to relish the constriction and find new ways of making the format work.

The difference in the purchase–usage ratio lies in the way we buy CDs. Given the "product" (music), it is debatable that anyone would buy a CD just for its packaging. Moreover, CD packaging is different from other types of packaging that "speak" to the consumer about its product's features and benefits. True, the CD booklet and tray insert reveal the track listing, and the CD's features, but most CDs are designed to identify a band or artist's new release and reveal information about the band or artists themselves on a more emotional level.

Some of this happens at the point of purchase, where the consumer can see the front and back face of the shrink-wrapped CD, but most of it happens post-purchase, in the comfort of our homes. Here, the packaging design reinforces our perceptions about the band or artist, reveals something of their character, pre-occupations, influences, concerns, and vanities. Sometimes, design contributes to the "relationship" we have with a particular group or singer, a feeling of compatibility, of shared pleasures. CD packaging is seemingly different because, on

Above: Very identifiable
The aim with the Pet Shop Boys' *Very* album was to develop a new identity for a CD pack that would make it accessible and more distinctive in a competitive marketplace. The design solution, with its opaque, textured orange jewel case, provided a bank of color at the point-of-sale, and an eminently identifiable spine. Designed by Pentagram.

Right: Eye contact
A simple acetate sleeve, printed with fine stripes makes David Byrne appear to wink and turns this CD case into a thoroughly engaging piece of packaging. As Tim Hale of the UK's *ID* magazine says: "That's awesome in a retail environment." Designed by Doyle Partners.

the face of it, it has no rules, no sector cues, and no consumer preconceptions to cater to. And yet, browse through any large music store and you'll find some semblance of a design language for rock, reggae, rap, heavy metal, world music, country, jazz, classical, etc. Learning a "language" can seldom be such fun or so demanding.

Below: Unpoetic design
True to the album's title, Fantastic Spikes Through Balloon, Stefan Sagmeister photographed all the balloon-like objects he could think of (including sausages, fart cushions, and blowfish) and punched a series of holes through them. As Skeleton Key, the band, was keen that its audience did not read the lyrics while listening to the music ("This is not a poetry affair") the words to the songs are printed in reverse, readable only when reflected in the mirror of the CD.

Right: Drumming home the message
The name of the album, *A Joyful Noise*, by Chester Thompson, provided the inspiration for the design of this CD. The change in size and layout of the typography hints at the euphony of drum sounds to be heard on Thompson's album. Designed by Lippa Pearce.

CHESTER THOMPSON
A JOYFUL NOISE

Tropical Sunday
Written by Chester Thompson
Arranged by Otmaro Ruiz

Chester Thompson Drums
Michiko Hill Electric keyboard
Otmaro Ruiz Electric keyboard and solo
Peewee Hill Bass
Jay Leach Acoustic guitar
Steve Fowler Alto sax
Harry Kim Trumpet
Debra Dobkin Percussion
Walter Fowler Trumpet
Steve Fowler Alto sax and solo
Brandon Fields Tenor sax
Bruce Fowler Trombone

So-Soka
Written by Chester Thompson
Arranged by Otmaro Ruiz

Chester Thompson Drums/keyboard/programming
Michiko Hill Acoustic piano/electric keyboard
Otmaro Ruiz Electric keyboard
Peewee Hill Bass
Jay Leach Electric guitar and solo.
Debra Dobkin Percussion
Gerald Albright Tenor sax solo
Harry Kim Trumpet
Walter Fowler Trumpet
Steve Fowler Alto sax
Brandon Fields Tenor sax
Bruce Fowler Trombone

Homeland
Written by Chester Thompson and Kevin Toney
Arranged by Kevin Toney

Chester Thompson Electric drums/percussion
Kevin Toney Electric keyboard/acoustic keyboard
Michiko Hill Additional keyboard
Peewee Hill Bass
Gerald Albright Tenor sax solo
Mike Rosenblum channel programming

Drums are Loud
Written and arranged by Chester Thompson

Chester Thompson Drums and percussion
Akil Thompson Electric drums
Debra Dobkin Percussion

A Joyful Noise
Written and arranged by Chester Thompson

Chester Thompson Drums and percussion
Michiko Hill Acoustic piano/electric keyboard
Peewee Hill Bass
Jay Leach Electric guitar/steel drum guitar
Pamela Desert Hart
Michiko Hill
Peewee Hill
Freddie Fox
Rico Thompson
Akil Thompson
Chester Thompson
Ronda Yates
Brenda Walker
Greg Walker

Raw
Written and arranged by Chester Thompson

Chester Thompson Electric drums/vocal percussion
Michiko Hill Electric keyboard/acoustic piano
Peewee Hill Bass
Freddie Fox Electric guitar
George Duke Synthesizer solo

Jussa Thang
Written by Chester Thompson and Kevin Toney
Arranged by Kevin Toney

Chester Thompson Drums
Michiko Hill Electric keyboards
Kevin Toney Electric keyboards
Peewee Hill Bass
Freddie Fox Electric guitars
Harry Kim Trumpet
Walter Fowler Trumpet and Fleugel horn solo
Steve Fowler Alto sax
Brandon Fields Tenor sax and solo
Bruce Fowler Trombone and solo

Chunky
Written and arranged by Chester Thompson

Chester Thompson Drums
Michiko Hill Electric keyboard and solo
Otmaro Ruiz Electric keyboard
Peewee Hill Bass
Ronnie Laws Electric guitar
Debra Dobkin Percussion

Cool Groove
Written by Chester Thompson and Michiko Hill
Arranged by Michiko Hill

Chester Thompson Drums
Michiko Hill Piano
Kevin Toney Electric keyboards and solo
Peewee Hill Bass
Jay Leach Electric and acoustic guitar
Harry Kim Trumpet
Walter Fowler Trumpet
Steve Fowler Alto sax
Brandon Fields Tenor sax and solo
Bruce Fowler Trombone

1. TROPICAL SUNDAY
2. SO-SOKA
3. HOMELAND
4. DRUMS ARE LOUD
5. JOYFUL NOISE
6. CHUNKY
7. JUSSA THANG
8. COOL GROVE
9. RAW
10. ADDADATODE
11. AMAZING G

Ladies and Gentlemen you hold in your hand that rarest of things - buried treasure. To the cognoscenti Chester Thompson has always been the 'drummers' drummer', whether working with Frank Zappa, Genesis, Carlos Santana, Steve Winwood, George Duke, Phil Collins or a young Pastorius Adaptation to everyone else's ... threatened the sanity of a lesser man but ... a voice all of his own, a divine promise - "A Joyful ... from the scriptures by this master of his art,

Gift packs

Gift packs are interesting because the usual rules which determine a piece of packaging's raw materials, production, and transportation cost "efficiencies" are altered by the dynamics of the gift packaging market. In this market, design's role is to increase a gift pack's perceived value and to present a product, or combination of products, in as attractive a manner as possible as potential gift material. As a result, the economics of the outer packaging invariably change, giving designers greater artistic licence.

This designer's aim is to create packaging that reassures the purchaser that what they are buying is a present that reflects the esteem they feel for the gift-receiver, and makes the receiver feel valued and rewarded ("Oh you shouldn't have," you hear them cry). This results in packaging which exploits a huge array of structural and surface graphic devices to entice purchasers and enthral receivers.

Sometimes, the packaging becomes part of the whole gift, as is the case with Curiosity's Valentine's Day gift packaging for Armani (overleaf). More often, it becomes a symbol of packaging's transience, consigned to the garbage after its brief "moment in the sun".

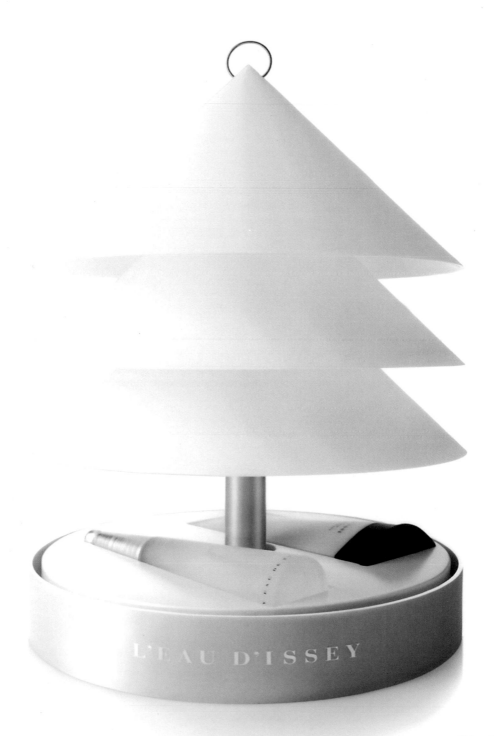

Below and right:
The gift of packaging
These two packs take gift
packaging onto another
plane. Created as a Valentine's
Day gift and a summer
promotion, they both use the
events as an opportunity to
indulge in packaging that is
witty, engaging, and beautiful.
Designed by Curiosity.

Innovative formats

Ten years ago, we struggled on beaches to apply our sun tan oils without dropping our bottles and getting ourselves covered in sand. Now we can simply stand and spray ourselves lightly and evenly with oil, the task of re-applying the oil after a swim also made so much easier. In Victorian times, breath fresheners were liquids that were gargled. Then they came in the form of handy-sized sprays, pastilles, and chewing gums. Now, we can choose fresh breath strips, like Wrigley's Extra Thin Ice, in dinky little pocket-sized packs.

The pace of new product development has had a concomitant effect on packaging design, as clients demand innovative solutions for their new products. Every year, designers and packaging manufacturers work together to explore new ideas and challenge existing conventions; to create new packaging formats for storing, displaying, and dispensing products, that keep a brand one jump ahead of its competitors. Designers frequently redress consumers' evolving needs.

Right: Rewriting the book
Why package a book? Why not, especially if you are trying to challenge they way people look at things and capture the unique character and vision of Paul Smith. The books featured 38 of Paul Smith's fabrics but you didn't know which one until you bought the book and opened the outer packaging. Designed by Aboud Sodano in association with Jonathon Ive.

Below: Creative injection
This specially developed packaging for Novofine combines product protection, storage, and portability. The carton engineering holds the products in place and folds to protect the needles when not in use. Designed by PI Design.

you can find
inspiration
in everything*

paul smith

*and if you can't, look again

Sometimes, innovation takes the form of looking at a packaging format typically applied to one product, such as vacuum-packed food, and applying it to a completely different product, such as clothing. At other times, innovation results from the designer understanding his or her client's brand and devising a packaging solution that's both effective and on-brand, while being completely different from its competitors

True innovation only derives from having an open mind. It usually only happens when there is a meeting of minds between the client and the designer, because it invariably requires more time, more effort, and more commitment to achieving the right result.

Right: Second skin
Speedo's Fast-Skin suits were worn by many of the swimmers at the Olympics. They draw their inspiration from a shark's skin with dermal denticles which minimize drag and maximize efficiency. As the suit has no straight lines to aid its folding, a net pouch was designed to hold the product (and act as a quick-dry bag), which is in turn held in a soft PVC pouch. Designed by Checkland Kindleysides.

Left: Shrink to fit
When design group Duffy invited its clients and friends to an exhibition in an art gallery, it chose this idiosyncratic shrink-wrap format to package their Asylum t-shirts that were given to each guest. Attendees were then invited to: "Put on their creative hats," and cut the shape of their own t-shirt.

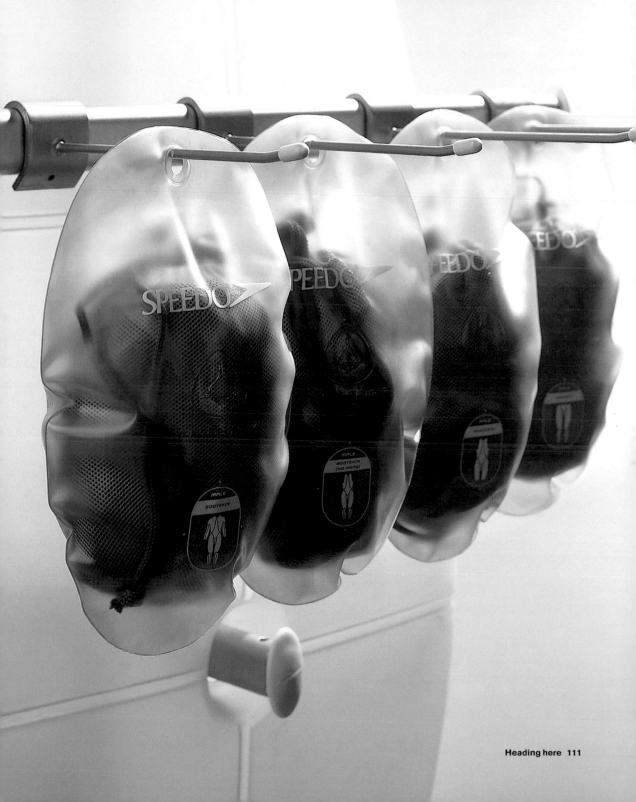

Materials

Materials selection is hugely important in packaging design. As we have seen in earlier discussions about particular packaging formats, such as bottles and cartons, the product being packaged often determines the choice of materials. The primary consideration at this point is that the product is preserved, protected, transported, displayed, and delivered in as hygienic and safe a manner as possible.

Material selection is also important in controlling consumers' perceptions of a product—both initial perceptions and more considered appraisal. These perceptions can be manipulated through the look of a piece of packaging and through the way the packaging feels in the hand. Most people instinctively associate certain attributes—such as quality, elegance, youthfulness, exclusivity, and trendiness—with certain looks and sensations. The silky smoothness of a piece of packaging or the clever marriage of different types of materials all coalesce into an impression of a product.

In some cases, the visual tone of a piece of packaging may derive from its use of a substrate like Polypropylene, which is typically seen as modern and contemporary. Alternatively, the visual tone may derive from the careful juxtaposition of different materials—some smooth, some textured.

As the two projects featured on these pages illustrate, the finishing of a piece of packaging—in both these cases through the use of hand-tied bows—can communicate the exclusivity and value of a product. The processes of unwrapping the product heightens consumers' expectations and suspends the pleasure of buying or receiving it. The amount of consideration given to materials is often in proportion to the price point of the

Above: Visible luxury
Langford & Co provide an exclusive corporate gift service. Its packaging, with a color palette of dark and light gray hues, uses high-quality materials to create a tangible sense of luxury and prestige. Designed by Pentagram.

Right: Higher design
The look of Christian Dior's *Higher* packaging is complemented by the feel of the product in the hand, not only in terms of its shape but also its weight and finish. Designed by Beef.

product itself. Invariably, the higher up the price curve one goes, the greater the attention to the look and feel of the packaging, and the greater the investment in materials. Yet materials selection can have such an influence on consumers' perceptions of a product that designers should consider it as a prerequisite of all projects.

Right: A bow on top
After years of creating fragrances for some of the biggest perfume houses in the world, Lyn Harris decided it was time to start her own brand, *Miller Harris*. The packaging has a classic, almost timeless feel. The materials it uses, such as the hand-tied bow, convey quality and value. Designed by The Nest.

Below: Big is beautiful
The Next Sempre carton is silky smooth, pale cream. The all-encompassing bow, in a richer tone, is heavily textured and literally rustles with life. For Sempre, the bow becomes the pack and provides the tension. When grouped, the square boxes create their own profile, making the packaging highly individual. Designed by Lewis Moberly.

Surface graphics

Mel Byars writes in his introduction to the book *Subtraction: Aspects of Essential Design,* by Alexander Gelman (2000): "The best and worst human characteristics that foster excellence may arguably be obsession and ego." In this next section, I hope to illustrate how designers' obsession with the surface graphics combines with their individual egos to create the best possible solutions.

Having worked in design for over 12 years, it seems to me that the very best designers really are obsessed when working on a project, and that ego—the desire to "win" and to be recognized for their efforts—really does drive them to excel. It also seems to me that, just as clients measure excellence using different indices (commercial effectiveness and personal preference, to name but two), designers also measure excellence using different criteria. Maybe this relates to the nature of creativity." I cannot name my favorite film, because different films are brilliant for different reasons. Maybe it's also the reason why two designers given the same brief will come up with two very different concepts. Whatever the reason, it is a vital part of the design process.

The really interesting aspect of this duality of obsession and ego is that all designers start with the same basic elements: typography, color, and so on. This book, like any, can only go so far in explaining what happens. I can demonstrate the elements and show how designers have used them but I cannot distill the alchemy that is a designer's imagination into black and white.

Right: Create your own
Each of these Massive Attack singles packs is unique because it uses heat-sensitive inks that react to the temperature of your hand. As a result, you "create" an element of the surface graphics as you hold the pack. Designed by Tom Hingston and Robert Del Naja.

Branding

In an age when brands are all powerful, it comes as no surprise that one of the primary constituents of surface graphics is branding. At its most basic level, branding declares ownership. Where the brand and corporate name are synonymous, the issue of brand display is simple: the design task is to display the brand name so that consumers can identify it during their initial product appraisal and selection process.

Where individual brands form part of a corporate portfolio (for example, the detergent Ariel as part of Procter & Gamble's broader portfolio), brand display encompasses both the individual brand and the parent corporation. In simplistic terms, this means that two identifiers need to be incorporated into the design—the "hero" brand and the endorsing corporate brand. Often, brand display is based on a hierarchy (where the hero brand occupies the front face, and the parent brand is featured on a side or back face), but display can also be affected by other issues, such as local market sensitivity to global brands (see page 20).

Whatever the brand display requirements, the designer's task is to feature the brand logotype and/or symbol in as eyecatching a manner as possible. Often this task can be achieved in a straightforward fashion by simply printing the branding as part of the color set. A brand's worth and its personality can also be communicated by employing devices like debossing or embossing, by using special effects like foiling or varnishing, or by positioning the branding in interesting relationships to the physical packaging. These effects and devices can communicate overtly—consumers' understanding being based on preconceived

Above and right:
Common thread
The branding developed for Levi's Re-threads—clothes made with everything from cotton scraps to shredded soft drinks bottles—wittily reinforces consumers' knowledge of the Levi's brand by using its iconic product—jeans. Designed by Turner Duckworth.

ideas of luxuriousness or frivolity—or they can act subliminally, as part of a brand's desire to engage consumers' senses and emotions.

Brand display often leads to a tension between size and aesthetics, where the requirement for brand impact challenges the creation of a sympathetically balanced design. "Make the brand bigger" becomes the mantra. Yet a brand's identity resides in more than just the logotype or symbol. Just as in corporate identity, where an organization is defined not just by its logotype/symbol, but by its color palette, typeface family, imagery, tone of voice, and so on, a brand is defined by more than just its mark.

Southgate coined the term "Total Branding" to describe this process of thinking beyond the mark, and it's useful in encapsulating a design attitude that embraces all the design elements to achieve a goal—a differentiated brand. Of course, a brand's logotype or symbol is a key element in the differentiation process, because their uniqueness can be legally protected, but they are not the only elements. The application of the brand device must be seen in the greater context of differentiation and proposition communication.

Right: The real thing
This pack manages to display Coca Cola's famous branding a total of eight times. It also recognizes the tremendous equity Coca Cola's Contour bottle (designed in 1915 by Alexander Samuelsson) has with consumers. Designed by Dew Gibbons.

Below: An all-round proposition
Here, the designer has managed to make both the brand large and create an aesthetically balanced pack by simply running the logotype around the packaging. Designed by Jones Knowles Ritchie.

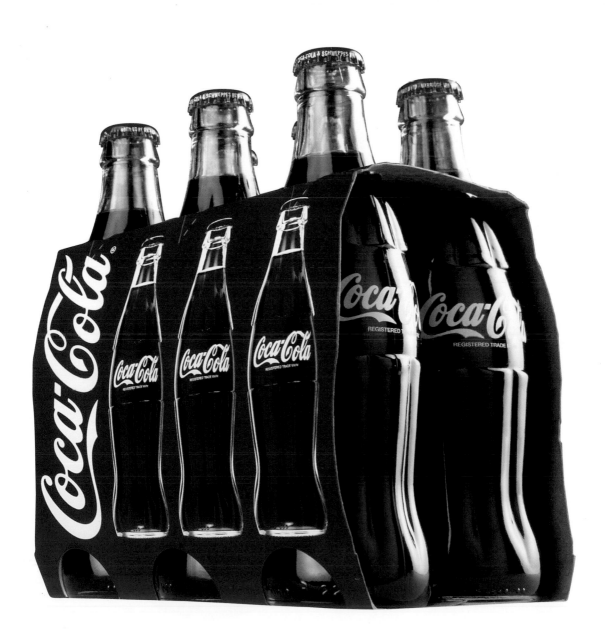

Typography

Typography lies at the heart of packaging design because it is essentially concerned with the dissemination of information. Products have names, descriptors, uses, benefits, variants, ingredients, components, instructions, safety warnings, customer care information, and ownership details. All of these details need to be displayed on the pack in a legible manner to enable consumers to read and understand the information they are looking at.

The modern typographer is faced with a bewildering array of typographic choices. Pick up any font library catalog and you'll find a huge selection of typefaces to chose from. Some of these typefaces are almost as old as the advent of printing—such as Baskerville, created by John Baskerville in the 18th century, and Bodoni, created by Giambattista Bodoni in the same era. Others are much younger—the products of computer technology and new software.

The designer's skill lies in matching typeface selection to function. Initially, the designer's task is to select a typeface that will display on-pack information in an easy-to-read format. Selection is determined by factors like pack size, information extent and printing methodology. Knowing a pack will need to feature a range of foreign languages (as is often the case with global brands) will steer a designer to choose a typeface that works at very small point sizes. Knowing a pack is to be printed using a relatively crude printing method may lead a designer to choose a typeface with open characteristics. and a lack of features—such as spurs and finials—which won't fill in.

Typeface selection is also influenced by other factors. If strong brand differentiation is the order of the day, then typeface selection can contribute to this process. Simply by assessing the

Right: Spanish spur
Sometimes, less is more. The simple but wonderful typographic twist to the "g" conveys so much about the Spanish provenance of this wine. What is more, its simplicity makes it stand out in a crowded marketplace. Designed by Pentagram.

Below:
Character injection
The Southern character of Cajun Injector is conveyed by the choice of typefaces and the way they are used. In contrast to Dehesa Gago on the opposite page, the label design is deliberately busy with "stories" about the product, and the typography complements this. Designed by X FORCE.

competitive set and choosing a different typeface to the rest can contribute to perceptions of difference. Alternatively, originating a new typeface, or manipulating an existing typeface to give it distinguishing features, can allow a brand to take ownership of a differentiating factor.

Typography can also play an important part in communicating a brand's positioning. If a product is to be perceived as classic or contemporary, or functional and honest, or handmade rather than manufactured, then the selection of the right typeface can contribute to this. When we think of typography, we tend to think of mechanical faces, set on machine, but it also encompasses hand lettering, and there are instances when this form of typography can set a product in the consumer's mind far more quickly.

Equally, typographic selection is important when considering a brand's personality. Just as people have characters, so do typefaces, and these characters can be exploited by designers. This character may be conveyed by the overall effect of the typeface—its boldness or delicacy—or by individual elements of a typeface—such as ligatures, ascenders, descenders, spurs, and loops—which imbue words with personality.

Many of the typefaces developed in Europe in the early 20th century were influenced by the Bauhaus movement, and its focus on function. Today, many sans serif faces created in response to this movement are perceived as modern and contemporary, and their use attributes these traits to the brands that adopt them. Conversely, products that want to be perceived as classic and luxurious, or those that derive from a historical or national tradition, may employ a serif typeface with the fluidity and ornament consumers equate with this type of personality.

Display
Humanist
Modern
Old Style
Script
Sans Serif
Slab Serif
Transitional

Right: Power type
The design of the Homebase Powertools packaging is characterized by the powertools in action. It is also characterized by typography that wittily demonstrates each tool's action. Designed by Carter Wong Tomlin.

Left: Fonts
As communication of the written word has become more diverse and sophisticated, so too have the typefaces in which it is depicted. Here are sme examples of how typography has evolved.

12V

Cordless Jigsaw

- For cutting straight or curved lines in wood, metal or plastic
- Cutting depth 55mm (wood) 6mm (metal)
- 0 - 45 degree cutting angle
- Locking on switch
- Dust extractor outlet
- Includes 3 assorted blades

POWERBASE

Jig saw

POWERBASE

18V

Rotary Tool

- For drilling, cutting, sharpening, engraving, cleaning and polishing most surfaces
- Electronic variable speed
- Lightweight, slimline design
- Spindle-lock mechanism for easy tool change
- Includes 60 piece accessory kit

Rotary tool

POWERBASE

140W

1/3 Sheet Orbital Sander

- For sanding flat surfaces
- 5 cutting or orbits
- Soft grip handle
- Dust extractor outlet
- Includes 10 sanding sheets

Orbital Sander

POWERBASE

14.4V

Cordless Drill Kit

- 10mm keyless chuck
- 16 torque settings
- Electronic variable speed, forward and reverse
- Soft grip contoured handle
- Includes 30 piece accessory kit

cordless Drill

POWERBASE

1200W

Circular Saw

- For cutting straight lines in wood or plastic
- Cutting depth 55mm
- Includes 185mm Tungsten Carbide Tipped blade
- 0-45 degree cutting angle
- Includes parallel guide
- Soft grip handle

Circular Saw

POWERBASE

1020W

Plunging Router

- For cutting slots and profiles in wood
- 2 - 44mm cutting depth
- 6mm and 8mm (1/4") collets for various size bits
- Variable speed
- Includes parallel guide
- Includes 5 Tungsten Carbide Tipped bits

plunging Router

POWERBASE

1600W

Heat Gun

- For stripping paint and varnish

Heat gun

Information layout and hierarchy

All packaging displays information to a greater or lesser degree. Typically, this information can be divided into different types, such as branding, naming, product variant, features and benefits, weights and measures, and so on. Often the amount of information seems to far outweigh the space available to portray it. The demands imposed by modern consumer protection legislation meet the needs of the brand owner, keen to ensure consumers understand the product and how it satisfies their requirements.

The challenge for the designer is to display this information in a manner that is distinctive, so that it supports the brand proposition, and helpful, so that it enables consumers to select the product he or she wants. The skill lies in understanding how to manipulate information layout to draw and hold the consumer's eye. The designer's gift also lies in understanding which information is most important to consumers at the purchase point, the moment of decision in the store, and the usage point, when information is being read in a different mode—at home, work, or leisure.

One of the primary factors to consider when designing packaging layouts, and creating information hierarchies, is the consumer and her or his shopping experience. Consumers don't conform to a type. Some like shopping, while others hate it with a passion. Some are very good at assimilating information and making purchasing decisions. Others (see page 40) may lack confidence in their ability to judge products against each other. These people look to the packaging to help them, and it is therefore important to know which factors will effect their decision, then prioritize them. Once the designer has established the central and peripheral messages, he or she can focus

Above: Perfect balance
These wines come from the Alentejo region of Portugal, a region characterized by flat lands, and blue, red, and white colors in its local architecture. These limited edition wines are very fine, a fact reflected in the exquisite, balanced, hand-drawn lettering, and script. Designed by Lewis Moberly.

Right: Enjoyable
When Lewis Moberly was commissioned to redesign Limmits' packaging, the visual language of the meal replacement category had become a cliché. Anemic white packs with washed out colors simply communicated diet without any reassurance that the product was either enjoyable or effective. In contrast, Limmits' packaging features mouthwatering photography, and dramatic black banding that differentiates it on-shelf, and provides a strong device for information portrayal. Key facts, such as calorie information, are easily identifiable, and all the more readable because of the packs' inate order.

Information layout and hierarchy 127

on using typographic selection and layout, typographic weight and color, and other graphic devices—like panels, symbols, icons, bars, and keylines—to lead the consumer's eye to relevant information.

The order of the day is balance, space, simplicity, and engagement. It is also about the measured relationship between the graphic form of the words and their content. Information layout and hierarchy should never lose sight of the fact that it serves a purpose and it's not just an aesthetic exercise. As Paul Rand says, in his book *Design Form and Chaos* (1993): "Form merely provides the spark without which content languishes."

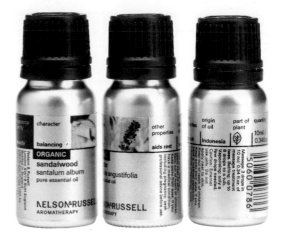

Above: Systematic information
Nelsons oils have been designed to address the needs of both experienced buyers and novices. The systemization of the information, combined with modern, metallic bottles, gives the range authority for those "in the know". The provision of information about the oils' source, character, country of origin, etc., makes the packaging accessible for first-time buyers. Typography, in both vertical and horizontal formats and weights has been carefully laid out to help the consumer. Designed by Lippa Pearce.

Right: Organic system
Interestingly, it's Modern Organic Products' information layout that defines its brand identity, as its packs are characterized by typography alone. The brand derives its authority from the systematic order of the information. Designed by Liska and Associates.

modern organic products

mop basil mint shampoo

for normal
to oily hair

shampooing
au basilic et
à la menthe
cheveux
normaux
ou gras

If your hair feels like
it's carrying the
weight of the world,
lift away dirt, pollu-
tants & oil with this
cleansing shampoo
containing extracts
of Certified Organic
Peppermint, Basil,
Sage & Rosemary.
Leaves hair fresh &
lively, full of healthy
shine & bounce.
Lighten up.

10.15 fl oz / 300 mL

Back-of-pack

Imagine a scenario where a consumer has been tempted into considering a product by the powerful proposition on the front face of the packaging. Either in-store or at home, she or he then turns the packaging around to learn more about the product or its usage, and is met with poorly laid-out information, in no particular order and with no particular thought given to her or his needs.

Back-of-pack design is the poor cousin of packaging design. Seldom given the attention they deserve, backs-of-packs betray the lack of time and care taken over them. Their poor designs suggest the product manager's or brand owner's scant concern for secondary information. In contrast, a good back-of-pack focuses on the type of information being displayed and the reader's needs. Considerable care and attention is taken over the choice, and weight of typefaces, keylines, colors, and icons, to lead consumers to information, and make it easy to assimilate, not to mention enjoyable.

Right:
Professional advice
This back of back is a perfect illustration of packaging where as much time has been spent on the back of pack as the front. Typography, color, numerals, roundels, bars, and panels have all been used to portray the information in a clear, legible and user-friendly manner. Designed by Newell & Sorrell.

Below: Animal magic
These sleeve wrapped bottles dramatically show how a whole bottle, not just its front face, can be considered when creating distinctive, powerful design solutions. Designed by Williams Murray Hamm.

Good designers also understand that packaging design is concerned with "telling stories" about the brand, and back and side faces can be used to illuminate particular features of the story or reveal different aspects of it. Treating a piece of packaging as more than just the front "selling face" means that any design becomes an holistic solution in both an aesthetic and communication sense. Good back-of-pack design also signals pride in the product and care for the consumers' needs.

Right: Leading layouts
The distinctive slanted typography on the front of these NBA Body Spray packs is echoed on the back. However, this stylistic device is achieved without sacrificing legibility. Designed by Lippa Pearce.

Below: Strong story
If every picture tells a story, then the story unfolds around this Waitrose Strong IPA bottle. Designed by Tutssels Enterprise IG.

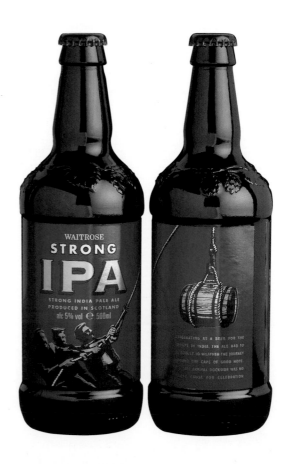

NBA

POWER SPRAY 1
DEODORANT
BODY SPRAY
200ML ℮

DIRECTIONS: POWER SPRAY IS A SPECIALLY FORMULATED FRAGRANCE FOR USE ALL OVER THE BODY. CONTAINS AN EFFECTIVE DEODORANT FOR LONG LASTING FRESHNESS. SHAKE CAN WELL. HOLD UPRIGHT AND SPRAY LIGHTLY OVER THE BODY FROM APPROXIMATELY 6 INCHES (15CM) AWAY.

WARNING: PRESSURISED CONTAINER: PROTECT FROM SUNLIGHT AND DO NOT EXPOSE TO TEMPERATURES EXCEEDING 50°C. DO NOT PIERCE OR BURN. EVEN AFTER USE. DO NOT USE IN CONFINED AREAS. DO NOT USE NEAR OR PLACE ON PAINTED OR POLISHED SURFACES. AVOID SPRAYING NEAR THE EYES. DO NOT SPRAY ON BROKEN OR IRRITATED SKIN. USE ONLY AS DIRECTED. KEEP OUT OF THE REACH OF CHILDREN.

DO NOT SPRAY ON A NAKED FLAME OR ANY INCANDESCENT MATERIAL. KEEP AWAY FROM SOURCES OF IGNITION. NO SMOKING.

AEROSOLS DO NOT CONTAIN CFC'S.

INGREDIENTS: ALCOHOL DENAT., BUTANE, ISOBUTANE, PROPANE, PARFUM, DIOCTYL ADIPATE, TRICLOSAN.

CAUTION: EXTREMELY FLAMMABLE

200ML
℮

SOLVENT
ABUSE
CAN KILL
INSTANTLY

Made Under Licence to
NBA Europe S.A.
Leaptrog UK LTD
Nottingham
NG1 5DU

5 010159 983029

Language

We have talked about the importance of creating an information hierarchy that consumers can understand and decipher. Information hierarchies work most effectively when allied to engaging and imaginative language.

Unfortunately, it's depressingly common for language to be given no thought at all by brand owners. Considerable time is spent creating and refining the packaging design but little time is given to the words that appear on the pack. Often this happens because the task of writing the words is given to a junior product or brand manager. Also, it can be the last thing to be done and, because production deadlines are looming, is given scant attention.

Yet the words on the pack are important for many reasons. They can engage with consumers and by "talking the right language", reassure consumers that the product is right for them. With so much emphasis on self-selection, consumers need help choosing the right product. They want to be able to understand a product quickly, and be able to identify one product's features and benefits over another.

Language can also demonstrate a brand's values, projecting values like authority, expertise, and efficacy, and demonstrate a brand's personality, projecting traits like youthfulness, fun, and passion.

Language can also differentiate one brand from another and it is vital in competitive environments to use every differentiating factor at one's disposal. I believe words are important to consumers because they contribute to the process of selection and preference, supporting a product's unique selling point (USP) and emotional selling point (ESP).

Right: Enjoyable detail

Some time ago, I read Tom Peters' book *The Pursuit of Wow* (1995), and he described buying a juice drink with the words "Use Before…" replaced with "Enjoy Before…". Ever since, I have tried on a number of occasions to persuade a client to do the same thing. This simple device says so much about Innocent's attitude to its product, and the experience it wants its customers to have. It also demonstrates the attention to detail that goes into every aspect of the Innocent brand. Designed by Turner Duckworth.

Left:
Philosophical language

One of the things that makes Barefoot Doctor such a good illustration of the power of language is the absence of imagery on its products. This focuses attention on the packs' predominant design features: color and typography. The design achieves maximum on-shelf impact through its dynamic use of a bright color palette. Having drawn the eye the packaging then "talks" to consumers in a manner that is both defining and engaging. It defines the personality of the brand, which in this case derives from a real person—the Barefoot Doctor himself —and engages with consumers on a product level and "philosophical" level. One learns what the product does —"make you damn sexy"—and the impetus behind the brand—"making the world a sweeter smelling place for everyone." What is more, it does it with humor and just the right amount of tongue-in-cheek. Designed by Leapfrog.

Photography

Imagery is a staple of much packaging design, because it is so immediate, powerful, and long-lasting. Imagery can encapsulate a core proposition, and communicate it quickly and effectively. Schmitt and Simonson cite research carried out into image recall which shows that imagery has the power to be recalled four times more often than words. They ascribe this effect to the distinctiveness of imagery, which enables it to be recalled relatively easily.

A significant percentage of the imagery used in packaging is photographic, whether it is color, black-and-white, or duotones. Images are created, to show the product, demonstrate its usage, communicate its benefits, or encapsulate the brand's essence. Sometimes, the content of the photograph is explicatory, showing the consumer what is contained within the box. At other times, photography may be metaphorical, seeking to encapsulate through an image an emotion or mood, the fulfilment of a desire or need.

A G Lafley, chief executive of Procter & Gamble talks about: "Winning the first moment of truth," when brand promise, and store price motivate the customer to buy. Photography, like illustration (discussed on page 142), has an immediacy that encapsulates the brand promise. Given the speed with which brand promise needs to be communicated, imagery has a distinctive part to play in engaging and retaining consumers' attention.

Photographic imagery also has the ability to differentiate one brand from another, not to mention one product from another. The selection of content, style of photography, cropping of the picture, and selection of color or black-and-white reproduction, all contribute to one brand being distinct from another.

Right: Integrity
The honesty with which the biscuit is featured on this packaging emphasizes the integrity of these products, produced on the Duchy of Cornwall Estates. The quality of the photography makes you feel you could almost pick up the biscuit on the box and eat it. Designed by Lewis Moberly.

Above: Values personified
Newman's Own are based on Paul Newman's belief in eating well, and his products reflect his goal to create nutritious, all-natural versions of his favourite foods. The packs feature Paul Newman and Joanne Woodward in a pastiche of the famous painting "American Gothic" by Grant Wood, imbuing the products with the attributes of these well-known characters. Designer unknown.

Right: Authentic images
Yattendon is a large farming estate with a thriving village. Its packaging features real characters who work in the village. The photographs not only root the breads in a very real English tradition but give the products authenticity. Designed by Atelier Works in collaboration with product specialists Factory Design.

two
Kentish
huffkins
ready-to-bake bread
made with Yattendon flour

YATTENDON ESTATE
RESPONSIBLE ENGLISH FARMING SINCE 1925

four
Frilsham
cheddarwells
ready-to-bake bread
made with Yattendon flour

YATTENDON ESTATE
RESPONSIBLE ENGLISH FARMING SINCE 1925

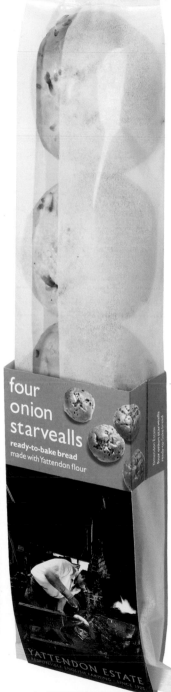

four
onion
starvealls
ready-to-bake bread
made with Yattendon flour

YATTENDON ESTATE
RESPONSIBLE ENGLISH FARMING SINCE 1925

Faced with two or three products to choose from, photography can also help reveal a product's features and communicate value, style, and desirability.

Photographic style is important because it is inextricably linked to the brand's personality and a product's positioning. Southgate believes: "The main factor driving the choice of a particular executional style should be the personality, or character, of the brand in question." The choice of color over black-and-white imagery, the composition and lighting of imagery, the dressing or propping of components of a shot, the retouching of imagery (to name but a few of the decisions designers make), all contribute to the consumers' perception of the brand, its personality, and its relevance to them.

Right: Dual-action packet
Howies is a small, ethical skate and bike clothing company. Its two key target markets, skateboarders and bikers, are addressed directly on the packaging—one on the front and one on the reverse. Both are shown interacting with abandoned furniture, commonly found in an urban environment. Designed by Carter Wong Tomlin.

Below: Witty repartee
Metaphor and wit are successfully employed in equal measure in these photographs for the Clarks Shoe Care range. The result is a range that is engaging and no less powerful in its communication of the individual product's benefits. Designed by Mytton Williams and Clarks' Company Design Team.

Left: Pedigree in black-and-white

The evocative, black-and-white photography forms a major part of the Chateau St Jean brand's identity, and creates a visual link between all of the different products. Its content and style does much to establish the pedigree of the brand. Designed by Pentagram.

Right: Photographic flavor

One of the primary objectives of food photography is taste projection, and these succeed very well. Presented on a simple white background each photograph oozes flavor. Designed by Duffy.

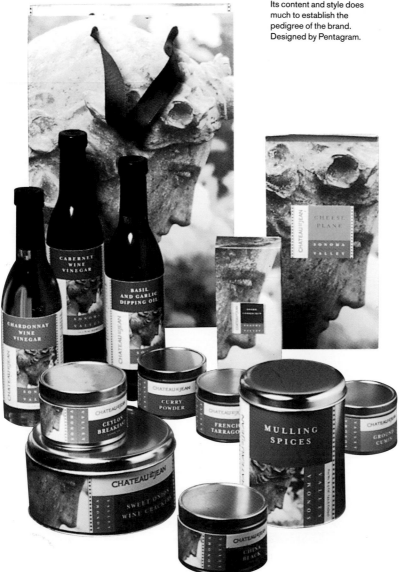

Illustration

Historically, illustrations were the primary method of featuring an image on packaging, but the invention of photography, and the development of printing technologies resulted in illustrations being used less frequently. This may be because illustrations carry with them connotations of craft and traditionalism, and in our modern, hi-tech world these notions are often perceived as outdated or irrelevant. It may simply come down to the designer's personal preference.

Illustrative imagery is still relevant today for a number of reasons. Firstly, because there are still packaging technologies and printing methods that don't allow photography to be used. Dry offset or silk-screen printing is unsuitable for four-color imagery because of the way ink is applied to the substrate. Accordingly, designers have to make a choice between using an illustration capable of being reproduced or omitting imagery completely.

Right: Traditional tale
Classico's authentic recipes for pasta sauces derive from old Italy, and the illustrations chosen to feature on the labels and caps emphasize the products' roots. Designed by Duffy.

Below: Monkeying around
Turner Duckworth was instructed by its client to have some fun with the beer's name and duly did so. The illustration's style and content helps support the idea that the beer is from a different time and place.

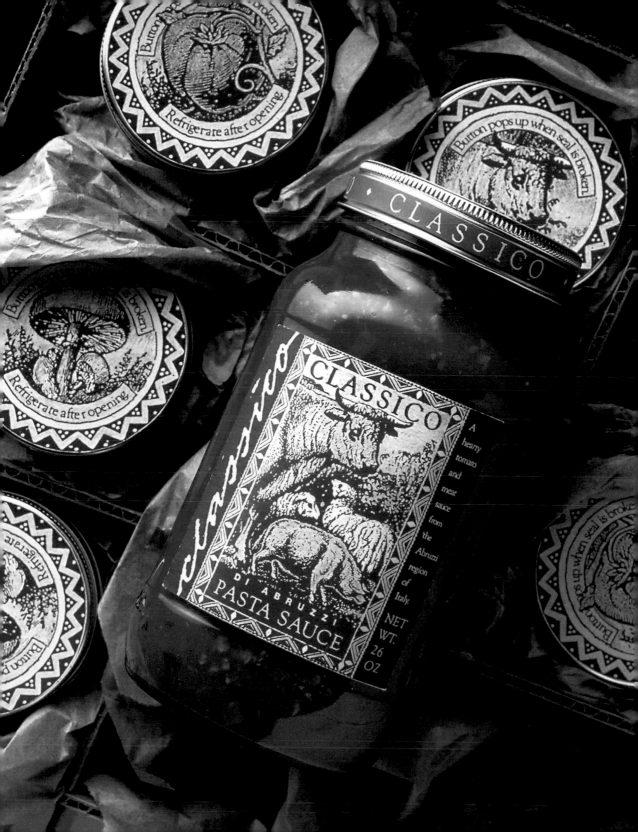

Illustration is also very relevant today because of the sheer variety of styles available. There are a large number of gifted illustrators working around the world. This means that the process of communicating the core proposition (the brand essence), of differentiating a brand or product, and projecting brand personality, can be achieved illustratively as well as photographically.

Of course, there will always be instances where a photograph will achieve the best result required, but as the work illustrated here shows illustrations can be modern, funky, natural, fashion-oriented, humorous, engaging... the list goes on. As with photography, it is the dynamic between designer and illustrator that brings a concept to life.

Right: Sex kitten
Benefit is a good example of a brand that employs a broad range of illustrative styles on its products—often witty and usually idiosyncratic. Its use of illustrations not only differentiates each of its ranges but captures the personality of the brand. Designed by Benefit's Company Design Team.

Below: Instant smile
This humorous play on the colloquial phrase, "Say 'cheese'" is used to great effect on this Woolworths single-use camera. Designed by Carter Wong Tomlin.

Illustration 145

Color

Color has many applications in packaging design. Firstly, it can be used as part of a brand's identity, helping to visually define a brand. Over time, and through a color's consistent use, a color becomes "owned" by a brand to such an extent that when a consumer sees the color, they immediately associate it with the brand.

One of the oldest examples of this is Bass Beer, which has been using its red triangle since 1855, and which famously features in a painting by Edouard Manet, *A Bar at the Folies Bergeres* (1881–2). The most frequently cited example today is Coca Cola. It is associated worldwide with the color red, so much so that Pepsi went through a massive rebranding several years ago and changed its brand color from red to blue, to differentiate it from Coca Cola. Every national market has its own examples. In the UK, Cadburys is associated with purple, and Colman's Mustard with yellow, while the American tool brand Stanley is inextricably linked with the colors yellow and black.

Color ownership by a brand is only achieved through consistent use of color, and the rigorous management of how that color is applied. Designers need to respect the brand's visual equity, creating new designs from an already predetermined color palette.

Secondly, color can be used to differentiate a product in its competitive set. Color therefore becomes an important visual discriminator that assumes different levels of importance dependent upon the amount of differentiation being achieved by other elements of the packaging. If the structural packaging for a product is not distinctive—such as a carton— then color, in combination with the overall concept, can contribute to greater on-shelf distinctiveness and stand-out.

Below: Color-coded
Color is used in several ways on these American GNC Vitamin packs. Firstly, it segments the range; secondly, it distinguishes different pieces of front-of-pack information; and thirdly, particular product features (such as "time released") are highlighted in a color-coded circular device in the bottom corner. Designed by Lewis Moberly.

Right: Rainbow range
Bottle color is used here to differentiate one L'Oréal Série Expert product from another. Designed by Beef.

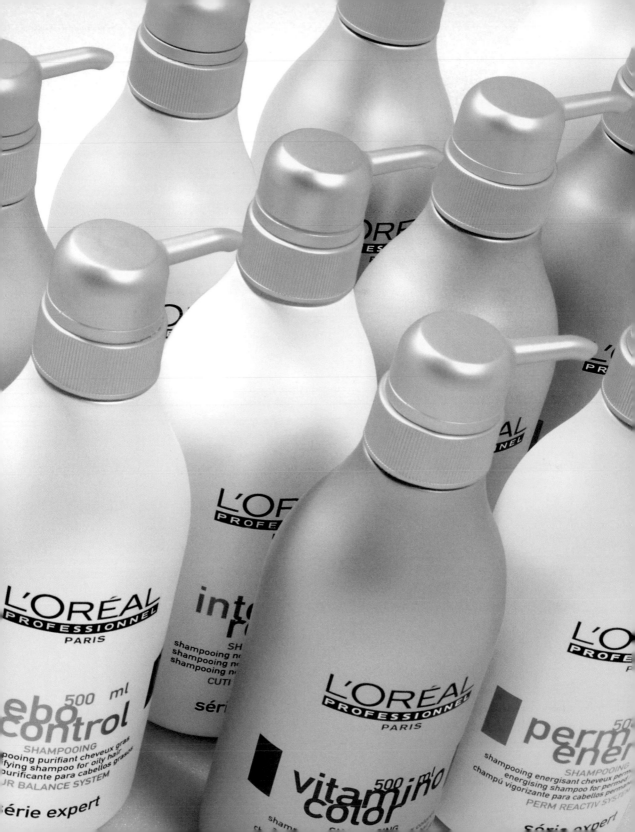

Thirdly, color is widely used to differentiate products in a range. Whether a range has two or three products, or over a hundred, which can be the case in food lines or cosmetics, consumers are looking for help in "navigating" a range's product hierarchy so that they find the right product for their needs. With smaller ranges, product selection may be as simple as choosing one flavor over another. Suncare lotions, for example, divide simplistically into products that help you tan and products that care for your skin when you've come out of the sun. Most of the major brands have chosen a color for each type of product to enable consumers to make the easy distinction.

With much larger ranges, the selection process may be complicated by the complexity of the range hierarchy. Cosmetic products, for example, divide into sub ranges—skincare, foundations, powders, concealers, blushers, lip colors, eye pencils and liners, mascara, eye shadows, and so on—and within each sub-range may then sub-divide by skin type or color. Structural packaging will help consumers identify products to a degree— eye pencils are clearly a different shape to foundations—but color can play an important role at the sub-range level in distinguishing one product from another—for example an oily skin from a dry or normal skin product. Consumers looking at the product display will be able to use color to understand there is a choice, while the brand owner can also use color to project the depth of its offer.

Color segmentation can be affected by market traditions. The brand leader may have introduced a color-coding system to distinguish its products, and over time, this has become the norm. Consumers understand the color-coding, and come to expect it. Examples of this are bread, milk, and paint. In the UK, where emulsion paints come in different finishes, blue is used for matt and green for silk. Understanding these norms is part of the process a designer goes through in the early stages of a project, when he or she is building the thinking that will inform the design solution.

Opposite: The new black
A singularly dramatic, and surprising, use of color unites this range of food products. In Selfridges Food Hall, which is a treat for the eye as well as the palette, these products stand out strikingly. Designed by R Design.

Right: Black and cream
The black and cream colors of Guinness' bottle mirror the drink itself, neatly turning the packaging into an encapsulation of the brand. Designed by PI Design.

FENNEL
BISCUITS

APPLE &
CINNAMON
BISCUITS

CHAMPAGNE
BRUT

Produce of France, MA-2851-20-00245,
Élaboré à Pargny-Les-Reims par Médot
et Cie à Reims, France.

CHARDONNAY
VIN DE PAYS
D'OC 2001

MERLOT
VIN DE PAYS
D'OC 2001

RUNNY
HONEY
WITH
HONEYCOMB

CLEAR
RUNNY
HONEY

CRANBERRY
& ORANGE
SAUCE

APPLE
& MINT
SAUCE

BLACK-
CURRANT
JAM

RASP-
BERRY
JAM

MEDIUM
CUT
ORANGE
MARMALADE

ORANGE &
WHISKEY
MARMALADE

Symbols and icons

In an interesting article in the journal *Brand Strategy* (March 2003 edition), Michael Peters of design consultancy Identica argues for an increase in the use of icons because of their intrinsic powerfulness and universality: "The road sign system is a great demonstration of using iconography to express valuable information in a simple way. No matter where you are in the world, or what language you speak, being able to heed a warning that the road ahead is bearing to the right, or understanding that you are approaching a steep gradient in the road is straightforward."

The ability of icons to communicate quickly and succinctly has resulted in their widespread use in packaging. This use is diverse and multi-functional. Just as an image can powerfully convey a brand proposition, so can a symbol or icon. As the Boots Repel Plus packaging (right) illustrates, these devices can sum up a brand's proposition very effectively, not only capturing the consumer's attention but communicating immediately and unequivocably. Deciding to use a symbol or icon can also form part of a brand's differentiation strategy.

Alternatively, symbols and icons can be used to reveal and explain a product's features and benefits, enabling consumers to evaluate whether it serves their particular needs or desires. The number of devices used can also be manipulated to convey a greater number of benefits than the competition, or to reveal the differences between a brand's range line-up. This is very useful with products such as power tools, where consumers actively compare and contrast one product with another.

Symbols and icons have many other uses. They can be used to support usage instructions, either assisting the written instructions or working on their own, as a sort of shorthand. Most paint cans use just such a combination of icons and text to simply explain to consumers paint application, coverage, drying times, and brush cleaning.

In our age of global brands, symbols are also used to identify language variants so that consumers looking at the back of a pack can locate their language quickly. Sometimes people use flags or country initials. Either way, such devices usually also save space, normally at a premium on the majority of global brands.

Symbols and icons have also now become the universally accepted means of communicating environmental, suitability, and warning information. Most packs now carry some form of environmental information, such as recycled or recyclable factors. Equally, food

Opposite: Power icons
As tri-lingual copy was a necessary component of Black & Decker's packaging, Duffy designed a series of icons to help communicate a large amount of information more quickly.

Right: No-go area
Powerful proposition, simple idea, immediate communication. Designed by Lippa Pearce.

2 · YEAR WARRANTY · GARANTIE · 2 AÑOS DE GARANTIA

MADE IN USA

7.2V

PLUNGE CAPABILITY · PLUNGE · CAPACIDAD DE PENETRACIÓN

LIGHTWEIGHT · LIGHTWEIGHT · LIGHTWEIGHT

BEVEL 0° BISEAU 45° BISEL

SEGURO DE LA FLECHA · SPINDLE LOCK · VERROUILLAGE DE L'ARBRE

DUST EXTRACTION · EXTRACCIÓN DE POLVO · DÉPOUSSIÉRAGE

DUST COLLECTION · RECOLECTOR DE POLVO · DÉPOUSSIÉREUR

800·762·6672

HOOK & LOOP PAD · HOOK & LOOP PAD · HOOK & LOOP PAD

DISK SIZE · DISQUE · TAMAÑO DE LA BASE 3 1/2"

WORK LIGHT · ECLAIRAGE · LUZ DE TRABAJO

CAPACIDAD CAPACITY CAPACITÉ 9" 228mm

HAMMER ACTION · MINE DE PERCUSSION · CAPACIDAD DE PERCUSIÓN

STROKES PER MINUTE · STROKES PER MINUTE 4500 SPM

REVOLUTIONS PER MINUTE · REVOLUTIONS PER MINUTE 4500 RPM

PIVOT HEAD · PIVOT HEAD · PIVOT HEAD 180°

BATTERY SYSTEM · BATTERY SYSTEM 9.6V

BRAKE · FREIN · FRENO

SAW BLADE · SAW BLADE 7 1/4" 184mm

2.5 HP 13.0 AMP

KEYLESS CHUCK · MANDRIN SANS CLÉ · PORTABROCAS SIN LLAVE

SHEET SIZE · DIM. DE LA FEUILLE · TAMAÑO DE LIJA 1/4

DEPTH OF CUT · PROFONDEUR DE COUPE · PROFUNDIDAD DE CORTE 1/48" 5.3mm MAX

WIDTH OF CUT · LARGEUR DE COUPE · ANCHO DE CORTE 3 1/4" 83mm MAX

PIVOT HEAD · TÊTE ROTATIVE · CABEZA GIRATORIA

2.5 HP

FORWARD/REVERSE · FORWARD/REVERSE · FORWARD/REVERSE

CHUCK · CHUCKÉ · CHUCK 3/8"

TIEMPO DE CARGA · CHARGING TIME 3 HR

SPEED · SPEED · VELOCIDAD 5

RANDOM ORBIT · RANDOM ORBIT

VARIABLE SPEED REVERSING · VSR

SCROLLING · CONTORNEA · CHANTOURNAGE

SHEET SIZE · DIM. DE LA FEUILLE · TAMAÑO DE LIJA 1/2

FORWARD/REVERSE · AVANT/ARRIÈRE · ADELANTE/REVERSA

REPETITIVE CHARGING · CARGA REPETITIVA · CHARGE RÉPÉTITIVE

CHUCK · BROCAS · MANDRIN PORTABROCAS 3/8" 9.5mm

BRAKE · FREIN · FRENO

KRYPTON GOLD

10"

packaging now carries a plethora of symbols or icons to alert consumers to a product's suitability for certain groups like vegetarians or nut allergy sufferers. Sometimes, this sort of product labelling seems to go to extremes; for instance when a supermarket labels a cucumber as being suitable for vegetarians.

Lastly, due to the dangers inherent in some product's ingredients or delivery mechanisms, packaging needs to carry consumer warnings about flammability, harmfulness, or abuse. Deodorants can explode if thrown on fires, and other products can be detrimental to the skin and eyes if carelessly handled. In this context, symbols and icons are often highly visible packaging features that alert consumers to take care.

Whatever use symbols or icons are put to, their strength lies in their intrinsic ability to communicate a message simply and universally. Designing these devices therefore becomes an exercise in reducing both the message and the format to the simplest of forms. Good symbols and icons transcend interpretation—their meaning is obvious to all who look at them.

Right: Visible elements
Icons are used on the front of Dead Sea Elements to communicate each product's benefits—such as soothe, refresh, moisturize, purify, balance, and nourish. Each icon is printed in silver foil to contrast with the other pack colors. Designed by Lippa Pearce.

Below: Clear and present danger
Standard warning symbols, used to alert consumers to the need to handle this product with care, are integrated into this spray paint can label. Designed by Lippa Pearce.

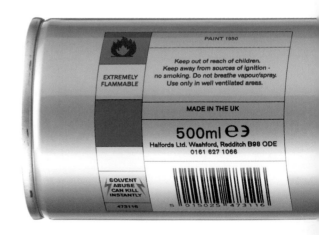

Finishes and effects

There are times when you look at a piece of packaging, or feel it in your hands, and you absorb feelings of quality, exclusivity, refinement and luxury. The packaging either imbues the product with these attributes or becomes valuable in its own right. In some sectors, like cosmetics, luxury goods and fine wines, and spirits, it is accepted practice to invest in finishes and effects that imbue packaging with qualities that engage consumers' attention and speak the right "language of quality".

Designers employ finishes and effects such as foil blocking, varnishes, laminates, debossing and embossing, and die-cutting or laser cutting. Each is used to manipulate consumers' perceptions or engage their senses so that what they see and feel communicates the right message.

Using these devices requires a light and discriminating touch. Use a finish too much, and it loses its saliency. Each finish or effect can communicate a very different message based on context (what sector of the market is the brand in), fashion (what is perceived as modern, contemporary, leading edge), and consumers' associations and expectations. In some cases, a high-gloss gold foil will look just right, but in other cases it may look garish, and unsophisticated. A gloss varnish may give a piece of packaging the necessary "lift" but in other markets more subtle matt or satin varnishes may communicate just the right note of elegance. Using pearlescent laminates on products aimed at the youth market, such as CDs, may strike the right note but would be completely out of context on other products like aspirational fragrance brands.

The packaging world is characterized by constant production and printing innovations. New finishes become available, and often

Right: Perfect foil
Foiling the De Beers logo signifies the brand's value and adds a restrained "moment" of contrast to the rest of the packaging. Designed by Dew Gibbons.

Below: Snappy design
The die-cut window in this packaging is used to witty effect. Designed by The Nest.

become the flavor of the month, but it is important that designers never lose sight of the fact that devices like embossing and debossing should support the brand proposition, not supplant it. Once again, it comes back to the brief and understanding how using such devices enables the packaging solution to attract, engage, and resonate with consumers.

Right: Gold-stamped
Foiling is often used as an accent or contrast finish. Here it is used exclusively on the front of the bottles to reinforce the rarity of the sherry. Designed by Blackburns.

Below: Fellissimo's box
The effect of this packaging derives from the wonderful surprise you get when you open the box, and from the supersaturated colors. Designed by Sayuri Studio.

Weights, measures, and barcodes

All packaging is required to carry some
information relating to weights, measures
and barcodes, and each country has some
agency that administers, and "polices" the use
of the correct information and symbols. Much
of this information is required to protect the
consumer and regulate the weights and
measures of products.

Equally, products from all countries in the
European Community, USA, Canada, Australia,
and Japan all carry barcodes, comprising a
country identifier, manufacturer's reference
number, and then a set of unique and identifying
digits, as they have now become an invaluable
part of retailers' and manufacturers' supply and
demand processes. From the designer's point of
view barcodes are an invaluable way of tracking
the sales of a product, and demonstrating the
commercial effectiveness of design.

Designers need to understand the legal
requirements for information, in particular the
requirements relating to the display of certain
types of information together on the primary
selling face, as well as the restrictions relating
to the display of barcodes, as their omission
or incorrect use can be costly.

Comic code:
A novel approach to barcode
placement was taken for the
design of this Clinomyn
Smokers' Toothpaste pack.
Design by The Chase.

Portfolios

So who to choose to illustrate the range and diversity of packaging design solutions?

I wanted to start by gathering work from designers operating around the world, and not just from the so-called "design capitals" of the world, like London or New York. Design is a large, and diverse community and I felt it was important to at least try and show work from all of the continents. Perhaps in doing this, different styles and sensibilities would come to the fore. For me, one of the intriguing aspects about Curiosity is that it was co-founded by a French and a Japanese person, two individuals with quite different cultural heritages and visual language backgrounds, which in turn filters through their work.

I also wanted to illustrate the work of designers whose focus is mainly on packaging design, and to show work from practices who have a more multi-disciplinary approach. My own practice works across design disciplines, and we often talk to clients about the positive effect it has on our design teams to be working on a variety of different projects at any one time. We also talk to them about the way identity design for example can influence packaging design, and how print design can affect the design of information graphics. To a large extent, it's having an open and receptive mind, and understanding how, for example, devising messages for brochures can help you create powerful on-pack communications.

Within the practices featured, there is also a demarcation between those still headed up by the founders, and larger groups (often with more than one office in more than one country). Practices like Pentagram and Turner Duckworth, not to mention ourselves, believe strongly in the active involvement of the principals in design rather than just practice management or marketing. Duffy, with offices around the world, is different, yet its work demonstrates a collective aesthetic, and a focus on quality, imagination and creativity.

Last but not least, I have included the work of Shiseido, as an illustration of the work of an in-house design studio. There are a huge number of designers all over the world employed in in-house studios. I thought it would be interesting to feature the work of one that has consistently produced work of imaginative flair, refinement, and quality, and which clearly illustrates a recognition of design's contribution to its brand.

There are bound to be people who disagree with my choice, but I hope at least they will find inspiration in the work featured, as well as affirmation that packaging design really is imaginative and powerful… and endlessly reinventing itself.

Arnell Group

On its website, the Arnell Group says it "creates and enhances the proprietary value of branded assets for major marketers who value innovation and transformation. Our contribution is in helping to identify and address strategic opportunities through innovation, and the constructive disruption of conventional thinking.

Ultimately, we provide consumers with compelling emotional and experiential brand interactions, and businesses with the assets, ideas, strategies, creative, communications, products, and associations they need to elevate their image, sales, reach, and appeal."

A wholly-owned, stand-alone subsidiary of the Omnicom Group, the Arnell Group is a different type of design company to some of the other practices featured in this section, but no less committed to producing interesting work of quality and style.

Premium reserve
Packaging for premium Don Julia tequila, made from 100% blue agave, grown in the valleys of Mexico. The topographic map label reflects the region of origin, while the rustic cap and woven leather pouch are a modern twist on Mexican handcraft traditions.

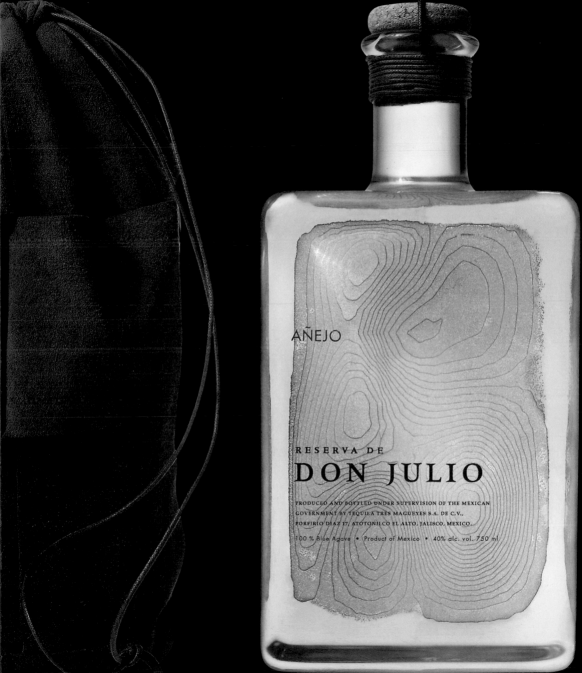

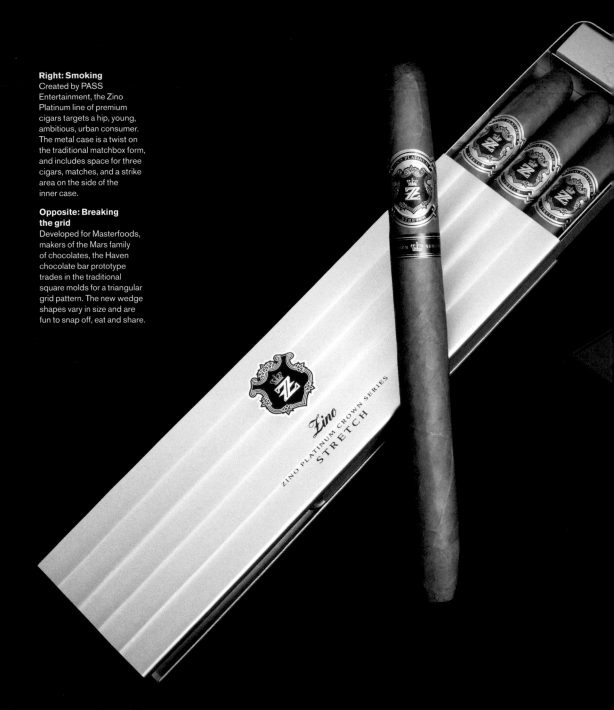

Right: Smoking
Created by PASS
Entertainment, the Zino
Platinum line of premium
cigars targets a hip, young,
ambitious, urban consumer.
The metal case is a twist on
the traditional matchbox form,
and includes space for three
cigars, matches, and a strike
area on the side of the
inner case.

**Opposite: Breaking
the grid**
Developed for Masterfoods,
makers of the Mars family
of chocolates, the Haven
chocolate bar prototype
trades in the traditional
square molds for a triangular
grid pattern. The new wedge
shapes vary in size and are
fun to snap off, eat and share.

chocolate

haven

MILK CHOCOLATE NET WT 1.51oz 43g

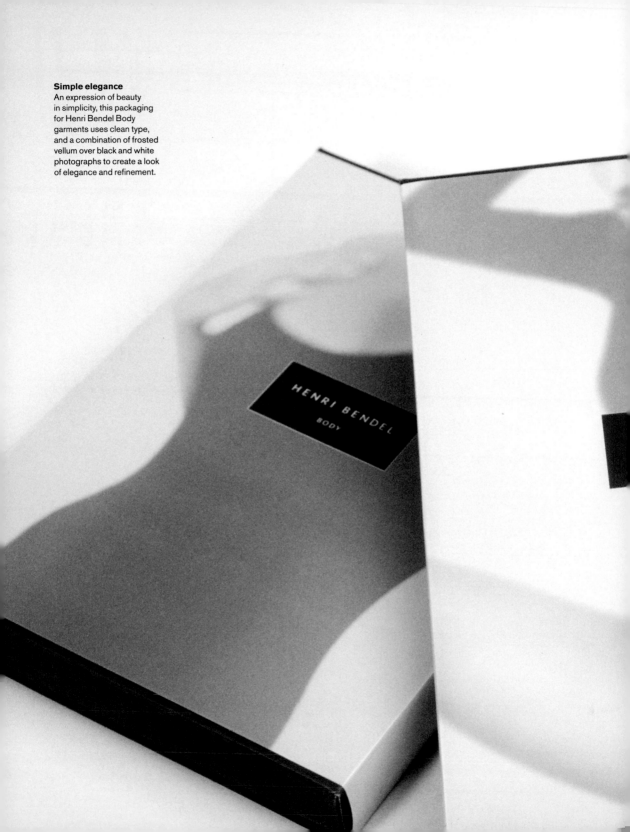

Simple elegance
An expression of beauty in simplicity, this packaging for Henri Bendel Body garments uses clean type, and a combination of frosted vellum over black and white photographs to create a look of elegance and refinement.

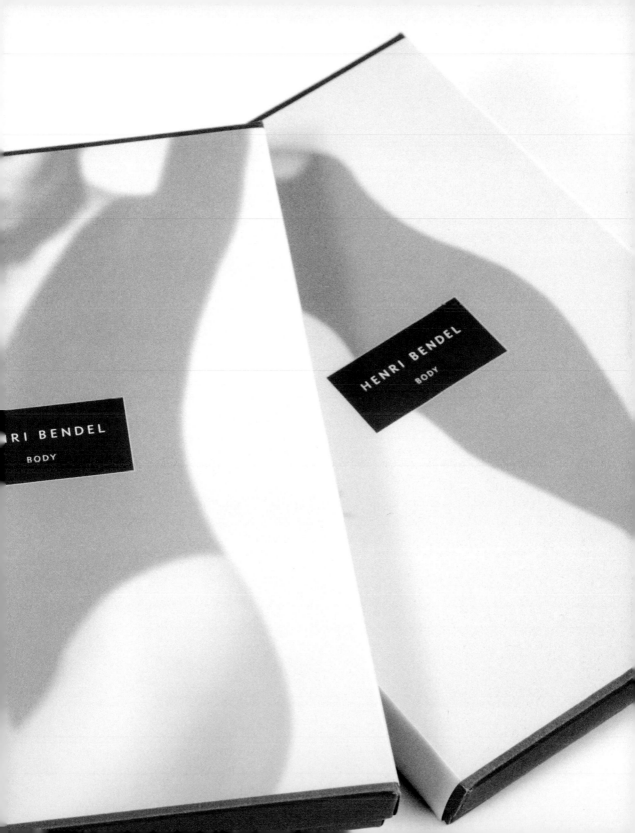

PLAYBOY UNDERWEAR

brief

PLAYBOY UNDERWEAR

tank

Curiosity

Curisoity is a Tokyo-based design office that
was set up in 1998 by the French designer
Gwenael Nicolas, and his Japanese partner,
Reiko Miyamoto. Its work covers various fields
of design, such as cosmetics, products,
furniture, and interiors; for clients like Henri
Charpentier, Jean Paul Gaultier, Kanebo, Issey
Miyake, Yves Saint Laurent, Levi's Dockers,
Nintendo, Pioneer, Sony, Tag Heuer, and Van
Cleef and Arpels.

In Curiosity's book *Perfume X Perform*,
the journalist Noriko Kawakami describes its
approach: "Creating an atmosphere around
an object which can then spin off in a flow of
time is the crux of how Curiosity's designs work,
no matter what the designers are dealing with.
This urge propels Gwenael Nicolas, Reiko
Miyamoto, and all the members of Curiosity,
beyond the territorial boundaries of design,
so they keep on creating stories."

Reading what Curiosity says about itself, it
is clear that it prizes invention, perfect simplicity
and 'paths of discovery' that enable people to
interact with its packaging and products, above
all else. The work featured is a perfect illustration
of this philosophy. Visually, the work is stunning.
It is also clearly about surprise and discovery,
about touch and sensuality, and about turning
the utilitarian—a piece of packaging—into
something of beauty, and value.

Right: Non-packaging
The triumph of this Issey
Miyake Me packaging is that it
works because of its context.
In essence, a simple tube
which holds the clothing,
enabling it to be displayed in
a vending machine-type
display, and transported
home, the packaging derives
its value, its equity, from
its brand environment.
Consumers recognize what
the Issey Miyake brand
means, and therefore accept
this piece of unadorned
"non packaging".

Left: Floral beauty
Nature and flowers are two
of Van Cleef and Arpels'
sources of inspiration for its
jewelry and the same two
inspirations lie behind
Curiosity's design for the
fragrance Murmure.
It wanted to create a shape
that was simple, modern but
also somehow timeless, and
beautiful. The graceful, slim
shape of the capless
fragrance bottle rises to a
sculptured head, reminiscent
of a deep-throated flower.

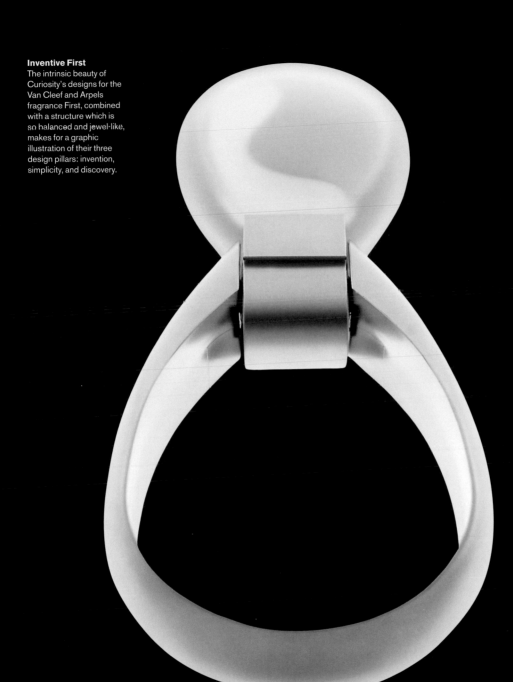

Inventive First
The intrinsic beauty of
Curiosity's designs for the
Van Cleef and Arpels
fragrance First, combined
with a structure which is
so balanced and jewel-like,
makes for a graphic
illustration of their three
design pillars: invention,
simplicity, and discovery.

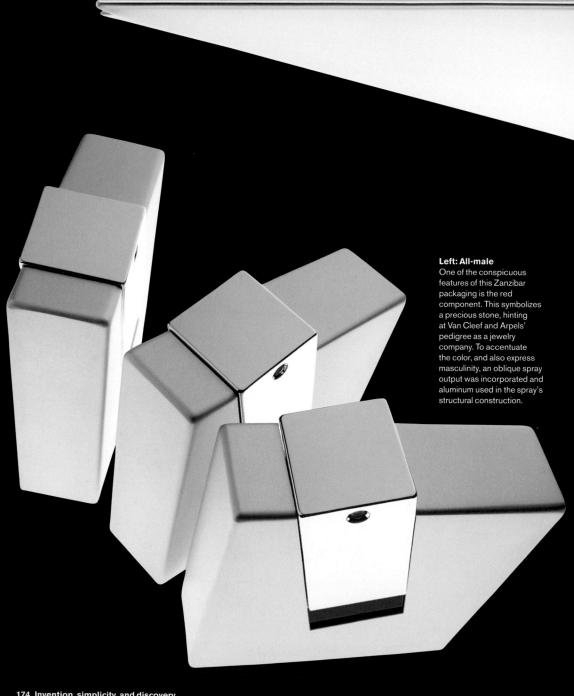

Left: All-male
One of the conspicuous features of this Zanzibar packaging is the red component. This symbolizes a precious stone, hinting at Van Cleef and Arpels' pedigree as a jewelry company. To accentuate the color, and also express masculinity, an oblique spray output was incorporated and aluminum used in the spray's structural construction.

Above: Own-brand
Curiosity's own perfume
is surely a labor of love,
an investment of time, and
expertise, to create a product

that with Jean Paul Gaultier, you are dealing with a brand that generates a host of associations in consumers' minds. To my mind one of these association is wit, and the design of Le Male Vapo Biscotto is wit personified.

Right: Essential quality
Attention to detail and minimalist impact imbues this whole range of Japanese essential oils. The bottom of the cone-shaped bottle is round and swings with a slight touch. This not only moves the oils but engages the user with its rhythmic effect. The outer packaging, with its three-step opening process, communicates the quality and preciousness of the oils.

Doyle Partners is a New York-based studio
that designs packaging, identity programs,
magazines and books, CDs, installations,
signage, environments, and even products for
a broad roster of clients.

"What distinguishes our work," says creative
director Stephen Doyle, "is that we start each
project with an examination of the context of the
finished work. We try to understand the mind-
set of the customer, and the environment in
which the product will be experienced." As
a result, the practice's packaging design
engages consumers' attention and minds with
its directness, clarity, and inventiveness.

What characterizes Doyle Partners are
discipline and imagination in equal measure.
The variety of the projects it works on keeps the
designers fresh, and by limiting the number at
any one time, keeps the practice focused on its
clients' needs. What unites all of the designers
is: "An honest passion for the power of
communication and dialogue—and an overriding
determination to get the colors right".

Slick set
Metallic paper adds some
racy chrome to the
Guggenheim's boxed set
of *The Art of the Motorcycle*,
Easy Rider, and *The Wild
One*. The combination of bold
typography, and engaging
use of photography adds
up to a motivating piece
of packaging.

THE ART OF THE
MOTORCYCLE

EASY RIDER

THE WILD ONE

INDONESIA | Bali | Golden Rain

Nonesuch Explorer is an archive of over 90 world music CDs, holding indigenous music from all over the globe. To accompany its re-issue, Doyle Partners repackaged the archive using bold black-and-white photography, from Magnum photographers—like Henri Cartier-Bresson, Abbas, Marc Riboud, and Rene Burri—to convey a feeling about the music rather, than attempt a direct illustration of it. The CDs employ a color-coded system that helps differentiate regions, countries, and titles and gives the series a graphic identity in record stores.

AFRICA | Animals Of Africa | Sounds of the Jungle, Plain & Bush

INDONESIA | Bali | Gamelan & Kecak

INDONESIA | Bali | Gamelan Semar Pegulingan: Gamelan of the Love God

INDONESIA | Bali | Music from the Morning of the World

INDONESIA | Bali | Music for the Shadow Play

AFRICA | Burundi | Music from the Heart of Africa

AFRICA East Africa Ceremonial & Folk Music

AFRICA East Africa Witchcraft & Ritual Music

AFRICA Ghana High-Life and
Other Popular Music

INDONESIA Java Court Gamelan

INDONESIA Java The Jasmine Isle:
Gamelan Music

AFRICA Nubia Escalay (The Water Wheel):
Oud Music

SOUTH PACIFIC Island Music

SOUTH PACIFIC Tahiti The Gauguin Years:
Songs and Dances

AFRICA West Africa Drum, Chant &
Instrumental Music

INDONESIA West Java Sundanese Jaipong
and Other Popular Music
Idjah Hadidjah, vocals

AFRICA Zimbabwe The African Mbira:
Music of the Shona People

AFRICA Zimbabwe The Soul of Mbira:
Traditions of the Shona People

Left: Fifties feel

Mambo Sinuendo is the last album recorded by Ry Cooder in Cuba, and is a collaboration with Manuel Galbán. The CD has been designed to evoke the sparkle, shine, and freedom embodied in the 1959 Fleetwood Cadillac, and the idea of hitting the road with the radio blaring. 1959 was the last year of car imports before the US imposed its embargo, so this was the year when automotive history simply stopped on the island. Printed on foil card, the photograph has been grained up, lending it the character of Technicolor, poor printing, and a little bit of rum rolled into one.

Right: Flemish flair

The elegantly playful packaging for Brewery Ommegang draws on the Belgian flag, Flemish iconography, and Tintin cartoons. Tom Kluepfel, creative director at Doyle Partners, describes his inspiration: "After visiting the Ommegang festival in Brussels, I was immediately drawn to the irresistible pageantry and wit of Belgium—a fiesty, and proud nation, where brewing is a revered trade, and partaking is a passion". The designs for each ale are eye-catching, and, upon closer inspection, spout unlikely Belgian wisdom like: "The first American brewer was a Belgian who arrived on the Mayflower."

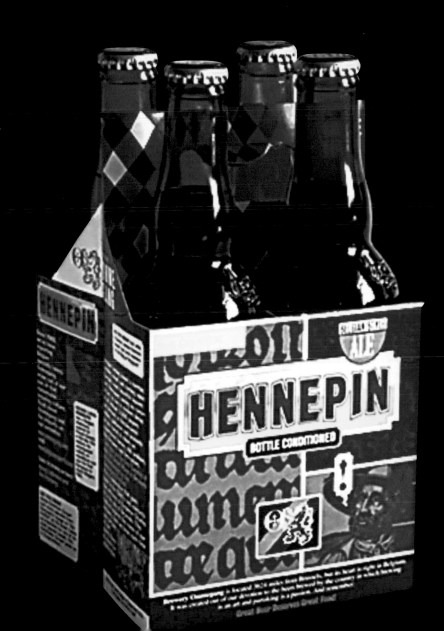

Everyday design
Doyle Partners's design for
Martha Stewart's packaging
creates a powerful visual
identity, and brings cohesion
to a huge range of products
encompassing Housewares,
Home, Baby, Garden and
Paint. Sold by Kmart, the
products often benefit from
40-foot runs of product,
providing the brand with a
huge in-store presence.
The packaging itself reflects
the Martha Stewart brand
principles of inspiration, and
information, being based on
product display, exuberant
colors, and accessible type.

Duffy began in 1984, when Joe Duffy, and Pat Fallon concluded that design, and advertising were two powerful marketing disciplines that—when combined and done well—could provide exponential results. It now launches new brands and revitalizes existing ones for some of the world's premier companies, some of whom are clients shared with Fallon advertising agency. Its client list includes Bahamas Ministry of Tourism, The St. Paul Companies, EDS, Nestlé Purina, Telecom Américas, Timberland, Starbucks, Sony, Skoda, BBC, Ben and Jerrys, and Noble House Leisure LTD, among others.

Although its has grown and evolved over the years, Duffy's core belief has remained the same; namely, design is one of the most powerful strategic tools a company can use to build a strong brand. That is not only what it believes, it has been its experience, and the reason it loves what it does.

To Duffy, it's really quite simple: "We marry our passion for creativity with sound thinking to deliver powerful design solutions. Whether you work with our team in Minneapolis, New York, London, Singapore, or Hong Kong, it's the same. We simplify the thinking. We amplify the creativity. The result is an emotional experience. Our team has broad experience, across categories and geographies. This provides a diverse perspective. It is a constant stimulus for our thinking and our work. The benefit to our clients and their brands is an interesting marriage of world-class design, from an objective eye."

Below: Glorious brew
The rediscovery of an authentic 1860s brewing recipe prompted the launch of this genuinely Southern brand—First Reserve—from the Flagstone Brewery of Winston-Salem, North Carolina. The brand positions itself as: "A beer as bold as the events that inspire it," and its design supports this proposition with pictorial, and textual references to bravery, glory, and honor. Above all, the use of the flags contextualizes the brand.

Right: Spirit language
All of the designs for Jim Beam's Small Batch Brands communicate the super-premium quality of these speciality bourbons. Duffy, who designed the labels, bottles, and packaging, demonstrate an intimate knowledge of the "language" of this sector, and the consumers who buy this type of drink.

Below: Authentic taste
The Sichuan Sauce range has been created by the restaurant Silkroad, in the Amara Singapore Hotel, which serves delicious dumplings and noodles. To give its sauces a homemade, crafted look, Duffy used traditional Chinese brush techniques, and a hand-tied covering to the jars' caps.

Opposite: Active thinking
Smartwool's sport socks are high performance and activity specific. Its brief to Duffy was to create packaging that would differentiate it from its competitors, and that would communicate the product's features, and benefits in a fun, and interesting way.
The pillow-pack format, distinctive color palette (and application of color), and use of cartoon-type illustrations, contribute to achieving this.

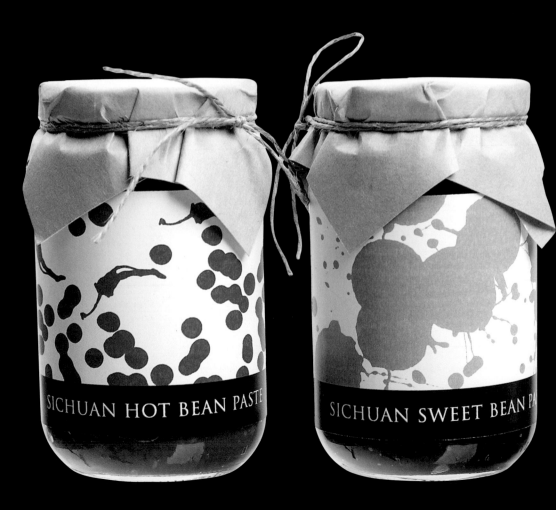

SICHUAN HOT BEAN PASTE

SICHUAN SWEET BEAN PA

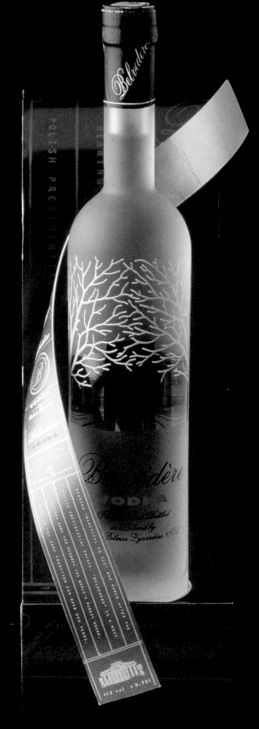

Left: Superior branding
Duffy's objective was to help establish the super-premium image of Belvedere Vodka and create a powerful on-shelf proposition. Both the gift box and bottle exploit design devices, such as "classic" typographic layouts, and illustrations, and finishes—such as frosted glass— to convey the superior quality of the product.

Right: Alco-pop
When the current trend of younger age drinkers (21–30) was moving away from hard liquor, alcoholic beverage companies looked to new areas to produce the next "cool" drink. Clash is intended to appeal to this audience. Its irreverent identity makes it a fun drink with a distinctive bottle shape, and a tactile feel.

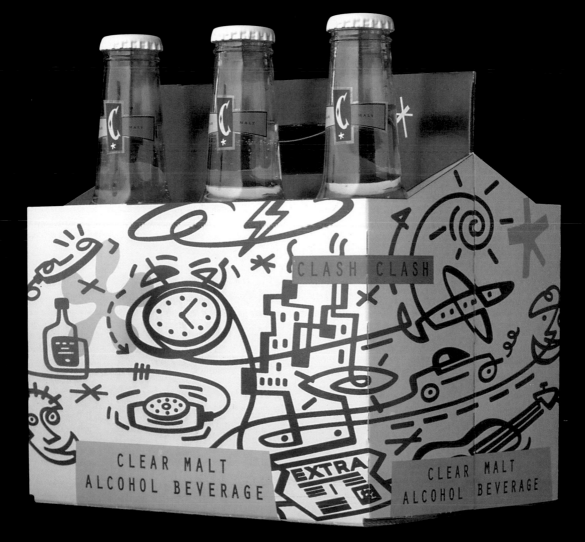

CLEAR MALT
ALCOHOL BEVERAGE

CLEAR MALT
ALCOHOL BEVERAGE

CLASH CLASH

EXTRA

Right: Quality control
Barrell 112 is bottled in
limited batches and the
design encapsulates this.
The bottle design is
characteristic of a sample
bottle, and the label is
fashioned after a quality
control form that is
signed, and stamped
by the brew master.

Opposite: Visual aids
Duffy's Singapore office
designed this range of
contact lens products. It
demonstrates how brand
identity and information
hierarchy can be integrated
into a whole. All the packs
have a visual integrity that is
both helpful and soothing.
The tripartite color palette
assists the information display
and conveys efficacy.

P / 2

Penta•Plex

MULTI-PURPOSE SOLUTION
Extra comfort formula
NO RUB

for cleaning, disinfecting & storing
of soft and hard contact lenses

TWIN PACK
INCLUDES 1 LENS CASE & 5 X 10ML UNIDOSE

P / 2

Penta•Plex

HANDY TRAVEL PACK

10 X 10ML MULTI-PURPOSE SOLUTION
1 X 10ML COMFORT DROPS
1 LENS CASE

Lewis Moberly

Lewis Moberly was founded in 1984, by designer Mary Lewis, and strategic director Robert Moberly. Based in London, with offices in Paris and Geneva, Lewis Moberly's expertise is in brand and design. Central to its work is its strategic brand, Visual Intelligence™. "Visual" represents its pursuit of creative excellence, and "Intelligence" represents its vigorously relevant and thoughtful approach.

Lewis Moberly and Mary Lewis are inextricably linked, and any description of Lewis is a description of the practice's collective philosophy and values. Perhaps David Stuart's view of Mary Lewis sums her up the best. Writing when he was President of the UK's Design and Art Direction (D&AD) organization, he said: "Let's start with the big stuff, the abstract nouns—passion, commitment, vision. She has them all in large measure. Like every winner (of the D&AD President's Award) she cares almost more than it's healthy to care about never for one moment allowing standards to slip… As a designer, she's out of the top drawer—or maybe the secret compartment concealed above it. I could witter on for pages about her classical restraint, her uncannily precise color sense, the balance between ideas and style."

The quality of the practice's work has been recognized over the years by the number of awards it has won—among them the British D&AD's Gold Award for Outstanding Design, three Design and Art Director Silver Awards, and the Design Business Association (DBA) Grand Prix Award for Design Effectiveness.

Right: Consistent differentiation
These wine labels, designed for Sogrape Vinhos de Portugal S.A., display a strong, cohesive visual identity, yet retain individuality. This is achieved through a consistent layout for the label copy, which creates a context for the wine and provides interest for the enthusiast, and symbolic imagery, which differentiates and visually summarizes each wine.

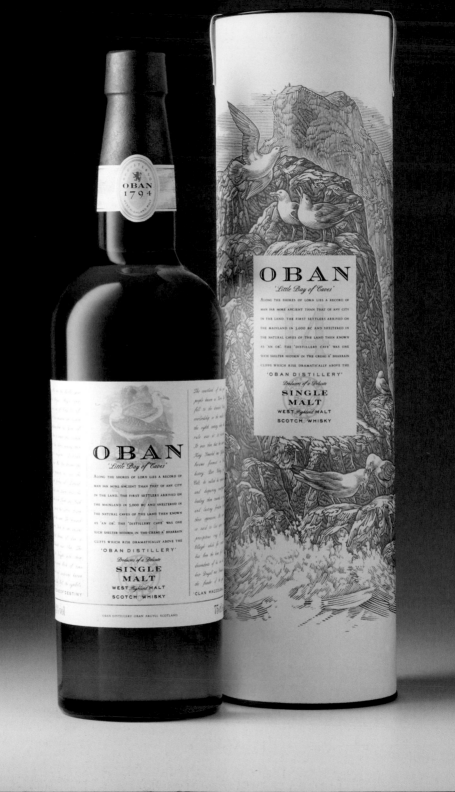

Left: Rugged reflection
Oban is a 14-year-old malt whiskey from the west coast of Scotland, with a distinctive character and individuality. Lewis Moberly's brief was to use design to embody the brand with authenticity, heritage, quality, and distinction. In response, its design reflects the bleak, rocky coastline of the region, with its squawking gulls and bracing winds. The long label copy tells the history of the region and distillery, rooting the drink in its distinctive and defining context.

Right: Mobile thinking
The brief was to create a new, contemporary graphic and structural look for Piz Buin's range. The new brand identity targets a younger, more style-conscious market, that responds to adaptable, ergonomic, portable accessories. Drawing its inspiration from the mobile phone silhouette, the new structure is highly distinctive within the category. Combined with minimal, confident branding, the new identity projects leader-brand status in a sector otherwise hide-bound by visual clichés.

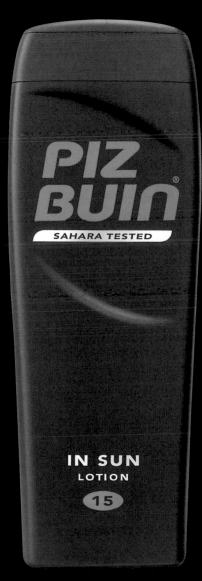

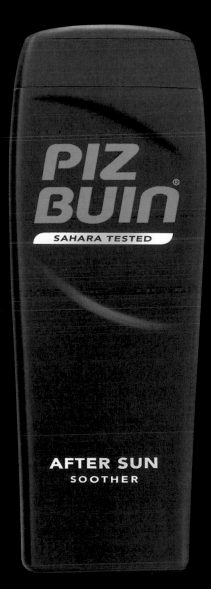

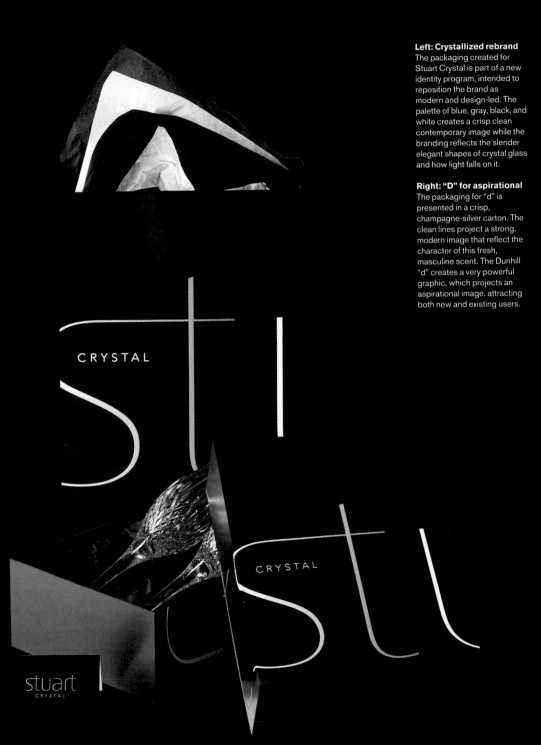

Left: Crystallized rebrand
The packaging created for Stuart Crystal is part of a new identity program, intended to reposition the brand as modern and design-led. The palette of blue, gray, black, and white creates a crisp clean contemporary image while the branding reflects the slender elegant shapes of crystal glass and how light falls on it.

Right: "D" for aspirational
The packaging for "d" is presented in a crisp, champagne-silver carton. The clean lines project a strong, modern image that reflect the character of this fresh, masculine scent. The Dunhill "d" creates a very powerful graphic, which projects an aspirational image, attracting both new and existing users.

CRYSTAL

CRYSTAL

stuart
CRYSTAL

Below: Direct approach
Teadirect needed to be
positioned between the
everyday and speciality
teas sectors and be highly
distinctive in a category
awash with cups of tea.
"Extraordinary ordinary tea"
commands attention as the
brand descriptor, setting
Teadirect apart from its
competitors. The design
features hundreds of 'tea

moments' which
microscopically make up
the central image of a tea leaf.
Each photographic moment
captures the gregarious
pleasure of people enjoying tea.

Top right: Cookie people
As the name suggests,
Bahlsen biscuits are intended
for the family, and the design
concept aims to project this
and reflect that Bahlsen is the
premium German biscuit
brand. When the packs are
positioned alongside each
other on-shelf they form a long
chain of figures holding
hands, creating a strong in-
store display.

Bottom right: Fruity
The fruit juice category can be
confusing to shoppers
because of the plethora of juice
types and product messages.
In response, Lewis Moberly's
design projects the premium
quality of the range by
communicating absolute
fruitiness. It also differentiates
the range, and provides clarity
of information to help shoppers
choose the right product.

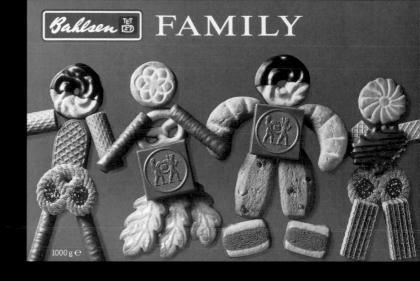

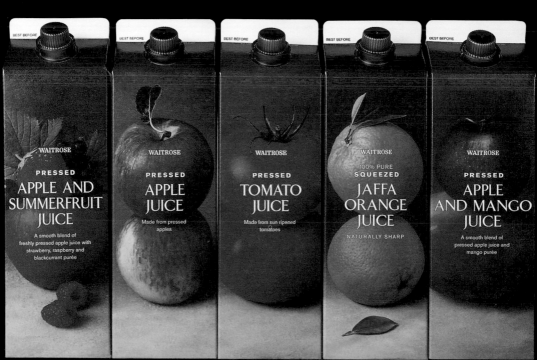

Lippa Pearce is a multi-disciplinary design consultancy founded by Harry Pearce, Domenic Lippa, and myself. Our work, in the specialist design disciplines of packaging, print, corporate identity, information graphics, and multi-media, has been exhibited world-wide and published widely in UK and international design and marketing journals. It has also won many prestigious awards both for its creativity (such as a D&AD Silver Award, Art Directors Club and Type Directors Club Awards), and effectiveness (such as a DBA Design Effectiveness Award).

Packaging design is one of the design disciplines we enjoy with a passion. Ever since we were first commissioned to design Gedi's Goats Cheese packaging in 1990 (it was only our second commission and we were still only three-strong) we have adhered to the same design principles: directness of idea, simplicity of execution, powerful engagement with consumers, and strong brand differentiation.

We value idea-based design highly and use different ways of thinking to arrive at our solutions. These encompass both "vertical and lateral" thought, intuition, wit, analysis, and social and cultural awareness. We also have a long-standing affection for all aspects of typography—indeed, it lies at the heart of all of our work.

Remover's concept supports the product proposition. Moreover, the idea, and its execution, uses humor to engage with consumers but not insensitively. We spent considerable time debating whether it was right to use humor for a medicinal product but felt in the final analysis that warts, while unsightly, are not a life threatening complaint.

Below: Fresh paint
When Halfords briefed us to redesign its Car Paints range, we were struck by three elements of the brief. First, the product is displayed in gravity-fed dispensers, which means only the cap, and top 40% of the can is visible. Secondly, customers want to know two things: is this paint the right color, and is it right for my model of car? Thirdly, consumers are notoriously bad at reading instructions properly before using the product.

As a result, they do things which ensure the product does not perform properly. Our design solution positions all of the important selection information in the area that is visible in the dispenser, and also orientates all of the usage instructions so that they wrap around the can, can be given more space, and use a larger, more legible typeface.

For customers in a burning hurry to apply the paint without the right preparation, we included a set of easy-to-understand icons that communicate the basic steps they must follow to use the product effectively.

HALFORDS
Ford
Citrine Yellow
Spray Paint

Opposite: Emphasizing the enjoyable

Geronimo Inns is a small chain of London-based, traditional bars with a modern twist. Our designs for the labels of its red and white house wines employ a traditional typeface, Gothic 13, in a contemporary way. Each label not only identifies the bottle's contents but exhorts drinkers to enjoy the wine with good food and the company of friends.

Left: Cool colors

For Kangol's first foray into the toiletries sector we created packaging synonymous with the brand's understated "coolness". The metallic-look cans have a soft, brushed feeling and a cap embossed with the Kangol logo. Fragrance identification is communicated using a simple, colored band running around the can. This color then becomes the background to the back-of-pack information panel.

Right: Plant power

Boots Botanics Range comprises over 500 products across a number of different categories like haircare, bodycare, skincare, cosmetics, and aromatherapy. Since its original launch the range has become one of Boots' most valuable brands with huge appeal to consumers looking for natural products that exploit the "power of plants". Our redesign of the packaging is part of Boots' plan to develop Botanics into a world-wide brand. It combines emotional engagement, through the use of beautiful x-ray plant photography, with information delivery on many levels: category identification, product differentiation, and benefit communication.

Opposite: Break from the classics mold

The record label takes a far more adventurous approach to classical recording than most other labels. Aiming at a more youthful audience, the designs use modern imagery and typography in an emotive and unconventional manner. The CD booklet designs reflect Virgin Classics' unique positioning within this competitive sector, and present the artists in a distinctive manner.

CLASSICS

pletnev

Scriabin

CLASSICS

piano concertos klavierkonzerte **9 & 20**

mozart

pletnev

deutsche kammerphilharmonie

CLASSICS

poulenc

Concerto pour deux pianos · Sinfonietta · Aubade

City of London Sinfonia

Jean-Bernard Pommier · Anne Queffelec · **Richard Hickox**

CLASSICS

poulenc

Concerto pour piano · Concert champêtre · Concerto pour orgue

City of London Sinfonia

Jean-Bernard Pommier · Maggie Cole · Gillian Weir · **Richard Hickox**

CLASSICS

SHOSTAKOVICH *The London Philharmonic*

Cello Concertos 1 & 2 MARISS JANSONS

TRULS MØRK

CLASSICS

paavo järvi

Sibelius

lemminkäinen suite royal stockholm philharmonic orchestra
luonnotar solveig kringelborn
nightride and sunrise

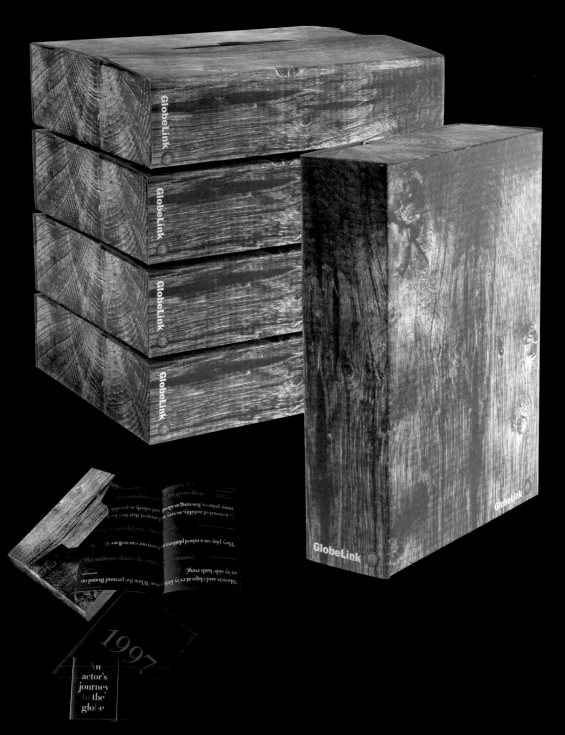

AUDLEY

Left: Global education
Globelink is an educational
program, encouraging
interaction between schools
and Shakespeare's Globe
Theater. Schools that sign-up
for the program receive an
initial pack of information
and then on-going
communications. We
"packaged" the initial
information in a box file

designed to look like one of
the oak timbers used in the
reconstruction of the
Elizabethan theater. Children
not only get a taste of what
they will see when they visit,
but teachers have a
distinctive, easily identifiable
box to go on their shelves.

Above: Feet first
Audley Shoes is an
idiosyncratic brand and this is
reflected in its boxes. They
feature two typographic feet.
The left foot, one's "rational"
foot, is formed out of a
structural analysis of a shoe.
The right foot, one's
"emotional foot" is formed
out of a whimsical poem
about feet.

Michael Nash Associates

Both ex-students of St Martins College, London, Anthony Michael and Stephanie Nash sat next to each other in class, and subsequently set up a partnership in the early 1980s.

With clients from the music and fashion industries, it has diversified over the years by building brands for a range of clients including Harvey Nichols Foodmarket, Boots, Ian Schrager Hotels (St Martin's Lane and The Sanderson), Space NK, Garrard, and The New Art Gallery Walsall.

The practice's work is admired by many and justifiably wins many prestigious awards. It has won a Gold and three Silver Design and Art Director Awards for its retail packaging and record sleeves. My own perception of the two principals is that they are passionate designers first and foremost, with an unerring eye for what is beautiful and distinctive, and for producing work which is irresistible to consumers.

Material difference
This covered sunglasses case with printed rubber band strap forms part of the overall brand identity created by Michael Nash for John Galliano. The eclectic mix of materials and elements (newspaper, rubber-bands, etc.) used across his packaging, labelling, and stationery reflects John Galliano's interest in combining found objects (both old and new) with modern technology to create something unique and individual.

southern sun
OAKENFOLD
ready steady go

Right: Classic modern
Using high-profile fashion photographers, Mert and Marcus, Michael Nash was briefed to take classic portrait shots of singer Sophie Ellis Bexter. The selected shots were then defaced with lipstick to give the covers a more modern attitude.

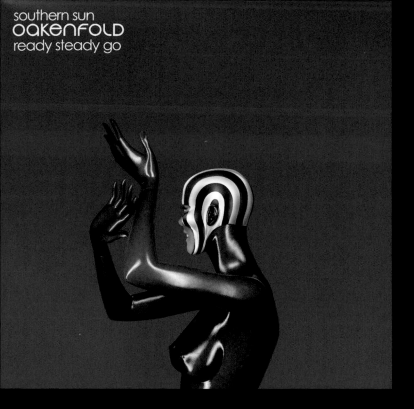

Above and right:
Superhero DJ
The idea for these covers was to create a surreal and colorful take on a superhero and produce each different version in different colors and finishes.

OAKENFOLD
bunkka

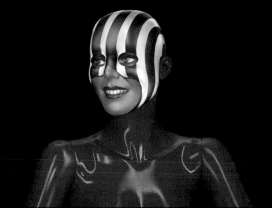

Right: First fruits
For their first album the Sugababes were shot by fashion photographer Liz Collins. The images selected for the album and individual singles were then overlaid with a large vintage fabric flower, sequins, old lace, and jewelry to create a feminine "collaged" mood.

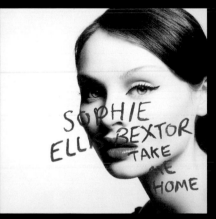

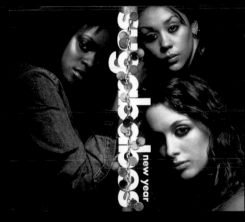

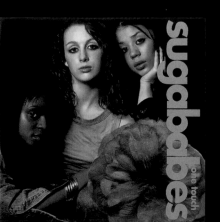

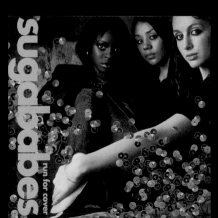

These bags are part of the retail brand identity for Space NK. They illustrate the color options available in the cosmetic market, and evoke the feeling of being in a candy store after school.

apothecary.SPACE.NK

Michael Nash Associates 215

Fashionable food

When Michael Nash was invited to design Harvey Nichols' food packaging it began with a question. "Why can't you wrap a jar of jam as you would a silk scarf?" In answer, its packaging treats food as if it was a fashion item. The design features simple white information panels, using the typeface Berthold Futura IT, and black-and-white photography with rich, sensory values. Michael Nash decided to illustrate the feeling of the food rather than represent it based on the premise that we all know, for example, what an olive looks like.

HARVEY NICHOLS

PANDORO

CLASSICO
WITH CHOCOLATE CHIPS

net wt 1000g ℮

PANDORINO

Pentagram

Pentagram was founded in 1972 in London and now has offices in New York, San Francisco, Austin, and Berlin. It is organized around the principals who operate as equal partners and who are all practicing designers. Currently there are 19 partners, including such luminaries as Michael Bierut, David Hillman, Kit Hinrichs, John McConnell, and Paula Scher.

The partners work independently or collaboratively, with one partner taking the lead on each project. Each partner has his or her own team, and one of the features of Pentagram's approach is that clients work directly with partners and designers without the intervention of account management. Pentagram also works collaboratively with other designers, and Lippa Pearce has experienced working with them on a project for Halfords.

The practice is multi-disciplinary, working across the full spectrum of graphics, identity, architecture, interiors, and products. It describes packaging design as "brand identity design at the sharp end—the art of promising and being believed. It represents the virtues and appeal of a product, according to the well-researched tastes and aspirations of the consumer. Shape, material, and mechanics become one with graphics to compete for attention, identify the product, and sell its unique qualities."

Architectonic type
A strong visual presence is achieved through the use of the bold, architectonic Trajan typeface, a dark elegant color palette of silver and gray, and the typography "playing off the edges of the product."

Left: Visual language
Baixas Lehnberg is a range of organic products produced in Tarragona, Spain. To distinguish it from its competitors, Pentagram created a visual language (consisting of a modern sans serif typeface and cropped photographs on a white background) to give the products a distinctly natural, quality and organic feel, and to communicate lightness, crispness, and freshness.

Right: Heritage brand
Columbus Salame has a rich Italian heritage which Pentagram was keen to communicate when it was commissioned to revitalize the company's brand identity and packaging. Columbus' portrait was redrawn in a style reminiscent of the late 15th century. The portrait's woodcut technique also helps give the brand a more classic look. The salamis themselves are wrapped with lustrous bucolic images, which make up a composite picture when packs are arranged together, and also give the meats a rich, premium feel.

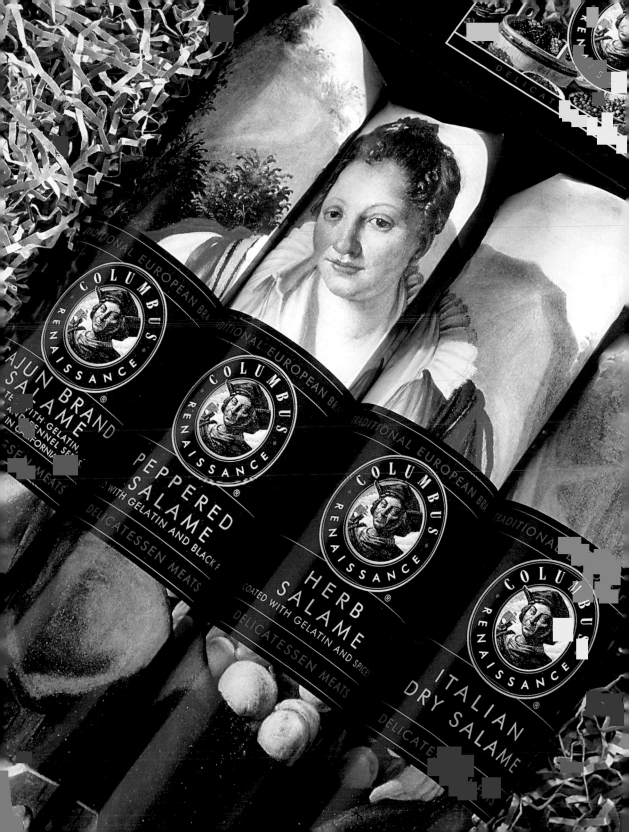

Below: Putting the balls into play

Having spent $170 million on research and development in creating a new golf ball, Callaway asked Pentagram to design the brand identity and packaging for its new product, called Rule 35. Its response was a multi-layered design solution. The "C" symbol is based on shapes found on the bottom of the cup—the ultimate destination of the ball. Red and blue were chosen to differentiate the two variants: Firmfeel and Softfeel. Graphics are embossed, giving the boxes a tactility that relates to the balls inside and is more sophisticated than the ubiquitous glossy or transparent packaging of other brands. Moreover, the packaging is a unique size which means that other brands cannot fit in Callaways' point of sale displays.

Right: Golfing science

Pentagram's packaging design's for Callways HX golf balls reveals the technological innovation that goes into the balls, while continuing to develop the graphic language that sets the brand apart. The boxes have been embossed, debossed, and treated with matt and gloss varnishes to give them a tactile quality that relates to the ball surface. In addition, all important information is featured on the covered sides of the box. The lid is short, exposing just enough of the information underneath to engage the purchaser.

Below: Emotive winner
Powerful attention-grabbing imagery combined with modern pack layouts all add up to Champion sportswear packaging that "talks" emotively to the target market, while the selective use of color to reinforce the branding gives the products strong shelf stand-out.

Right: Finest line
Pentagram's design for Tesco's Finest range has become a benchmark in the UK for a superior, multi-category, own-brand offer. I have used the range myself at a conference as an illustration of best practice. The components of the design, the asterisked range name, the sumptuous product photography, and the silver color scheme not only convey luxury but enable the range to stand out powerfully in-store, whether displayed together or seeded amongst different categories.

Shiseido

In 1872 Arinobu (Yushin) Fukuhara opened Japan's first western-style pharmacy in Tokyo's Ginza district, the country's bustling center of business and fashion. Over 100 years later, Shiseido is one of the largest and most influential cosmetic houses in the world, its products sold in around 60 countries. Its name, taken from a phrase in the Chinese classics and meaning "praise the virtues of the earth, which nurtures new life and brings forth new values," is a reflection of the company: "A pioneer in combining eastern aesthetics and sensibility with western science and business practices. Tradition joined with technology, oriental restraint expressed with occidental flair." Shinzo Fukuhara, Shiseido's first president, preached a philosophy of "let the product speak for itself" and these words have become the company's guiding principles in the creation of all of its cosmetics over the past 100 years. They have also influenced the design of the company's packaging, which reflects both the company's eastern origins and its western influences. Its first president, Shinzo Fukuhara, studied in *belle époque* France and the United States. As a result, the company's 19th-century product design and advertizing adopted a distinctive style strongly influenced by the Art Nouveau and Art Deco movements that were prominent in Europe at the turn of the century. In the 20th century, other influences can be seen. In the 1960s, American style functionalist design started to have an influence as the "material revolution", brought about by the introduction of plastics, led to a shift from curving to straight lines, from decorative to more functional purity.

see a concentration on simplicity and quality. It also saw Shiseido innovating with new printing technologies, such as the development of multicolor pressing and hot-stamp/vacuum metalizing, to create decoratively sensitive designs, combining tradition with creativity.

Shinzo Fukuhara founded Shiseido's Design Department in 1916. Today Shiseido employs 34 packaging designers, under the design leadership of Mr M. Shiokawa, deputy general manager of package creation department, and it continues to practice the company's philosophy of innovation combined with tradition, quality combined with creativity, consumer awareness combined with a strong design intelligence and sensibility.

Art deco influence
Modern Colour Face
Powder's packaging was
designed in 1932. It was the
first of Shiseido's packaging
to display images of women's
faces. The design illustrates
clearly the influence of the Art
Deco Movement on Shiseido's
design team at the time.
Even the camellia's delicate
pistil appears as a solid
geometric form

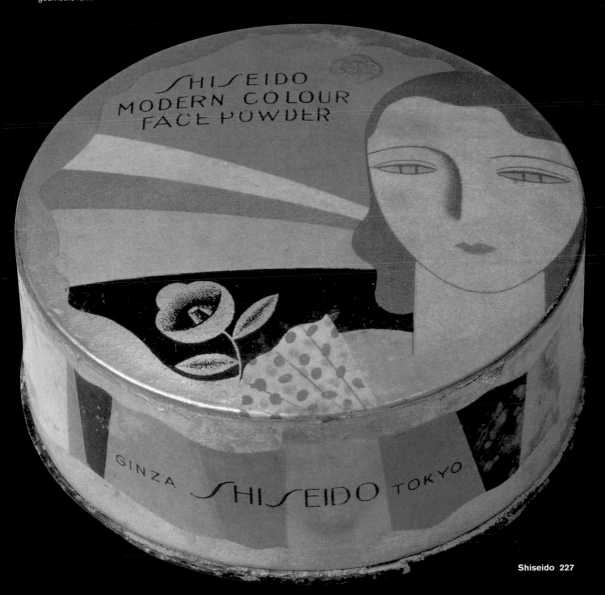

Above: New look

MG5 was Shiseido's first hugely successful skincare and cosmetics line for men. Launched in 1967 the range features glass containers with aluminized paper labels and resin lids. The range was a major transition in packaging design and utilized the latest manufacturing methods. Its bold graphics, especially its geometric black and diamond pattern against a silver background, epitomize the design aesthetic of the 1960s.

Right:
Collaborative process
The Untied collection of
men's fragrance, hair, and
skincare products was
designed in 1996, in
collaboration with the Italian
architect, industrial designer,
and poet Sergio Colatoroni.
In many ways it encapsulates
Shiseido's combination of
Eastern and Western design
philosophies with its marriage
of sculptural forms and
calligraphic branding.

untied

HAIR
TREATMENT
LIQUID

SHISEIDO
INTERNATIONAL

untied

HYDRO
CONCENTRATE

SHISEIDO
INTERNATIONAL

untied

CALMING
CONCENTRATE

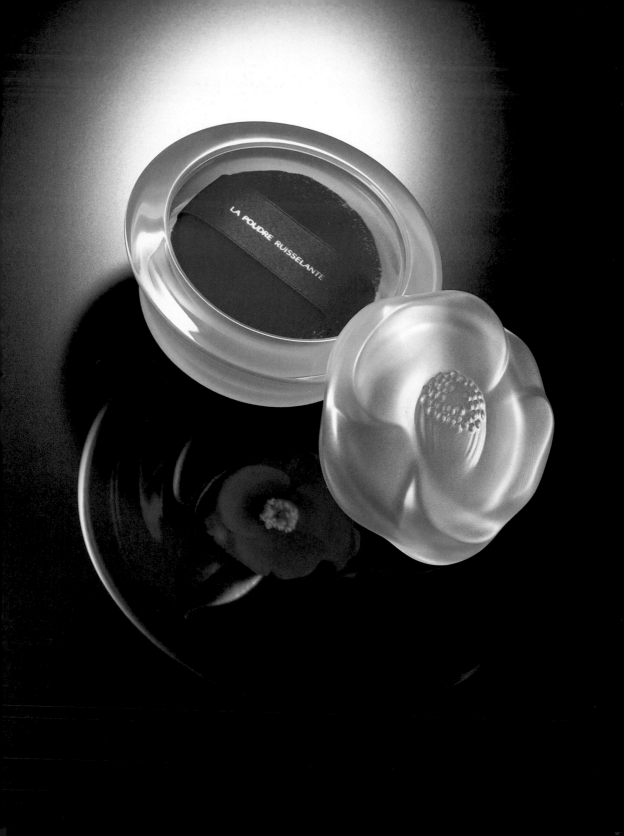

Right: Body and soul
Created in 2001, Qiora uses an alomachology technique to enhance the relationship between body and soul. The major objective of the packaging design is to convey the product's concept of "comfortableness". The form and color of the packaging have been selected to communicate visual and sensual comfort. In addition, the visual and sensual have been equally considered when the products are seen in isolation or grouped as a range.

Left: Delightful shower
La Poudre Russelante is a make-up range created in 2001 for younger customers. It employs a Camellia as a flower motif on its lid. This device harks back to the first president of Shiseido, Sinzo Fukuhara, who created the company's trademark, having observed Camellia flowers floating on water.

SHISEIDO PERFUME

Zen

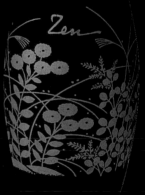

18th Century Inspiration

As Shiseido's first product developed for overseas markets, Zen was designed in 1965 to evoke Japan through its subtle fragrance and sophisticated packaging design. The traditional gold leaf floral pattern was inspired by a design in a Kyoto temple and echoes the more baroque Japanese aesthetic. The device recalls the traditional craft of maki-e, lacquerware painted and spinkled with gold. The gold string tied around the necks of the bottles alludes to the celebrated Japanese art of wrapping and packaging.

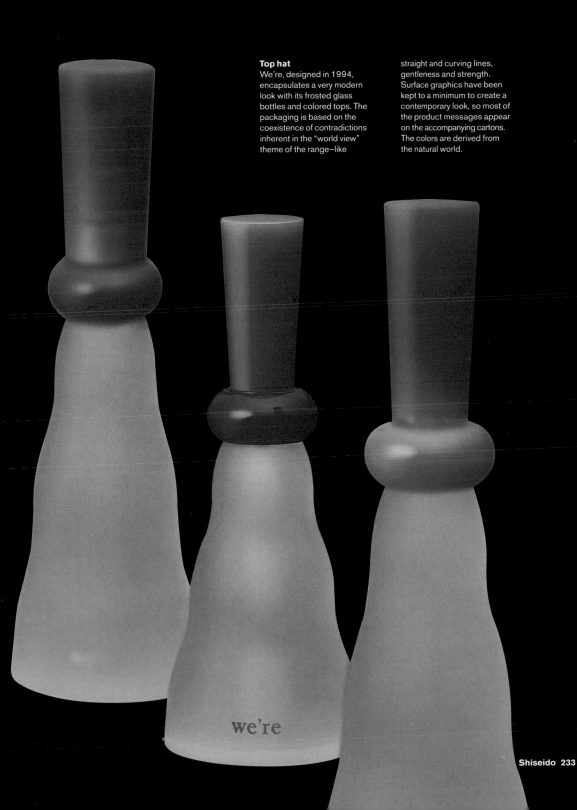

Top hat
We're, designed in 1994, encapsulates a very modern look with its frosted glass bottles and colored tops. The packaging is based on the coexistence of contradictions inherent in the "world view" theme of the range—like straight and curving lines, gentleness and strength. Surface graphics have been kept to a minimum to create a contemporary look, so most of the product messages appear on the accompanying cartons. The colors are derived from the natural world.

we're

Slover [AND] Company

Slover [AND] Company is a New York-based "boutique" design firm, small by design and now in its twentieth year. Its size (16 to 20 people, depending on its client mix), ensures the partners are actively involved, personally and materially, with the work it does. In its own words "There is no 'B Team' at Slover [AND] Company. Assignments that we cannot do to our standards of excellence, we simply opt not to pursue or accept. Failure is never an option".

Throughout the company's history, the firm has consistently blended this passion for design excellence with an equal commitment to maintaining, supporting, and sustaining the uniqueness of its clients. "By bringing the best of ourselves to the best of our clients, we have contributed to the bottom line of luxury clients such as Bergdorf Goodman, Saks, Lancel, Talora, Episode, Henry Cotton, Takashimaya, Nordstrom, Bath and Body Works, Sara Lee Intimates, and HUE, among scores of others. And we like to believe that we have also contributed both to the aesthetics of the marketplace... and the marketplace of ideas."

The firm believes it brings not so much an encompassing design philosophy to its work but a strongly held conviction about the way design should perform: "We want it to attract and to seduce. To be the whisper that cannot be ignored. The most glamorous person in the room, irrespective of age or heritage. Good design attracts the hand as well as the eye. And it must be different from the rest... but for all the most sensual reasons. Good retail design must call to the consumer, a siren's song of irresistibility."

Slover [AND] Company also believes that what it designs today must and will remain relevant in five years. Its work must balance cultural and temporal relevance with an appropriate measure of timelessness, to ensure that the drive to change, when that time comes, is powered by desire and not the business need to catch up with the competition.

Essential brand
Talbots is one of America's most venerable retailers, and its packaging illustrates its Bath and Body brand extensions–Essential Town, Essential Country, and Essential Shore. The 23-strong range is characterized by contemporary typography, muted feminine colors, and a debossed logo. All three combine to give the range authority and distinctive on-shelf appeal.

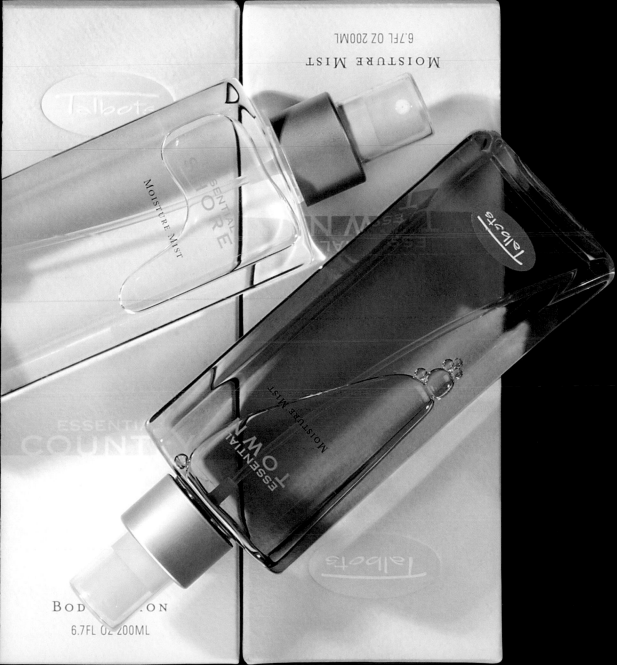

Scientific benefits
To communicate the natural efficacy of the Benefits products Slover [AND] Company combined crisp white cartons and labels with beautiful, stylized ingredient photography, and juxtaposed sans serif typography. The overall look is both natural and "scientific", with each product's benefits clearly identified.

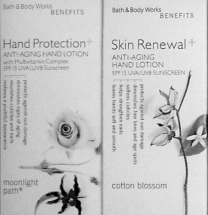

Bath & Body Works
BENEFITS

Hand Protection+
ANTI-AGING HAND LOTION
with Multivitamin Complex
SPF 15 UVA | UVB Sunscreen

protects against sun damage
diminishes signs of aging
nourishes cuticles and nails
restores a youthful appearance

moonlight
path®

Net wt. 1.7 oz / 28.2 g

Bath & Body Works
BENEFITS

Skin Renewal+
ANTI-AGING
HAND LOTION
SPF 15 UVA/UVB SUNSCREEN

protects against sun damage
diminishes fine lines and age spots
softens cuticles
helps strengthen nails
leaves hands soft and smooth

cotton blossom

Net wt. 1.7 oz / 28.2 g

Bath & Body Works
BENEFITS

Skin Renewal+
ANTI-AGING
HAND LOTION
SPF 15 UVA/UVB SUNSCREEN

protects against sun damage
diminishes fine lines and age spots
softens cuticles
helps strengthen nails
leaves hands soft and smooth

sweet pea

Net wt. 1.7 oz / 28.2 g

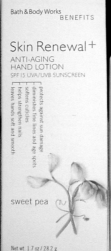

Bath & Body Works
BENEFITS

Hand Protection+
ANTI-AGING HAND LOTION
with Multivitamin Complex
SPF 15 UVA | UVB Sunscreen

protects against sun damage
diminishes signs of aging
nourishes cuticles and nails
restores a youthful appearance

mango
mandarin

Net wt. 1.7 oz / 28.2 g

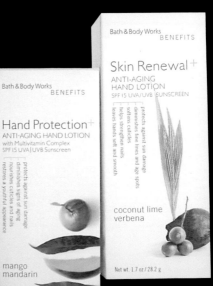

Bath & Body Works
BENEFITS

Skin Renewal+
ANTI-AGING
HAND LOTION
SPF 15 UVA/UVB SUNSCREEN

protects against sun damage
diminishes fine lines and age spots
softens cuticles
helps strengthen nails
leaves hands soft and smooth

coconut lime
verbena

Net wt. 1.7 oz / 28.2 g

Unique value
Slover [AND] Company's bags and boxes for Japanese retailer Takashimaya's North American flagship store feature asymmetrical lids, and die-cut slipsleeves that accentuate the retailer's branding. The subtle cream and gold color scheme infuse the packaging with style and quality, and make the consumer feel that her or his purchase is special and valued.

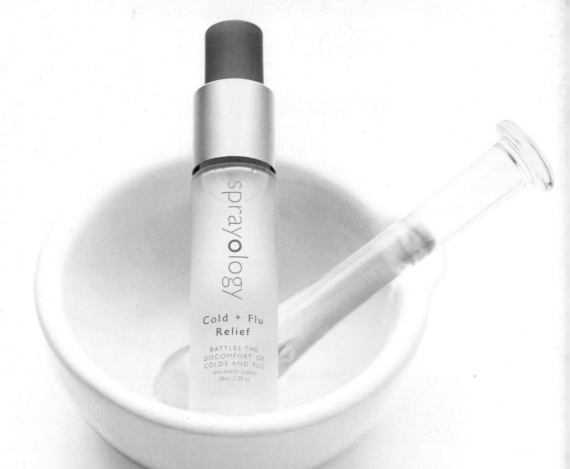

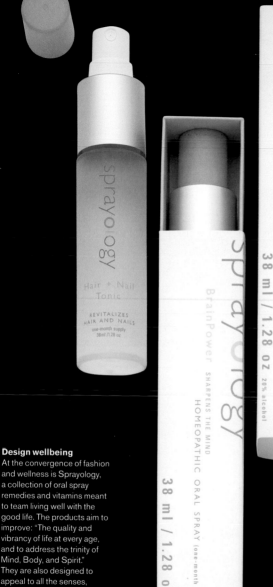

Design wellbeing

At the convergence of fashion and wellness is Sprayology, a collection of oral spray remedies and vitamins meant to team living well with the good life. The products aim to improve: "The quality and vibrancy of life at every age, and to address the trinity of Mind, Body, and Spirit." They are also designed to appeal to all the senses, and the packaging is equally multi-sensorial, engaging both sight and touch. The range is a good example of packaging designed to appeal to consumers' rational and emotional purchasing triggers.

Turner Duckworth

Turner Duckworth is unusual in that it has two offices: one in London, headed by Bruce Duckworth; and one in San Francisco, led by David Turner. Both the London and San Francisco offices operate as separate but equal-strength partners. One result of this set-up is that the practice has an enviable client list that embraces clients on both sides of the "pond" —clients like Amazon, Levi's, Mercedes Benz, Palm, Schweppes, and Superdrug. Another is that the two studios indulge in a bit of friendly rivalry that maintains a creative tension, and means they keep separate books.

Both studios practice a range of design disciplines and packaging is one where their work is well known, having won many awards for both its design and commercial effectiveness. Both Duckworth and Turner are strong advocates of packaging design. In a profile in *Graphis Magazine* (May/June 2001) Turner stated: "The reason a lot of our work is demonstrated in packaging is that, if you haven't got it right there, it really shows, because it's such a simple, distilled, bare expression of the brand. A package is a great discipline, in that it has to have all the inspirational things that a brand has to have, but it also has to satisfy the practical aspects, and finally it has to distil everything into an instant snapshot.The ad campaign can go after the central idea but to create a package that sums up and expresses the brand, then you have to know that brand better than anybody".

Turner Duckworth is relatively small and the two partners stay very involved with their clients and the design process. They have a work process which focuses on the issues, on ideas and on creative execution. Above all the two studios share a common element—passion— which is reflected in the quality of their work.

Packaging with a smile
Amazon has become known world wide as an on-line bookseller but the reality is that the goods and services it retails are much wider than this—in fact everything from A to Z. Turner Duckworth's new logo added a personal touch to the business by adding a broad smile to one of its most physical manifestations—its packaging. When presented with the new identity, Jeff Bezos, founder and CEO of Amazon said: "Anyone who doesn't like this, doesn't like puppies."

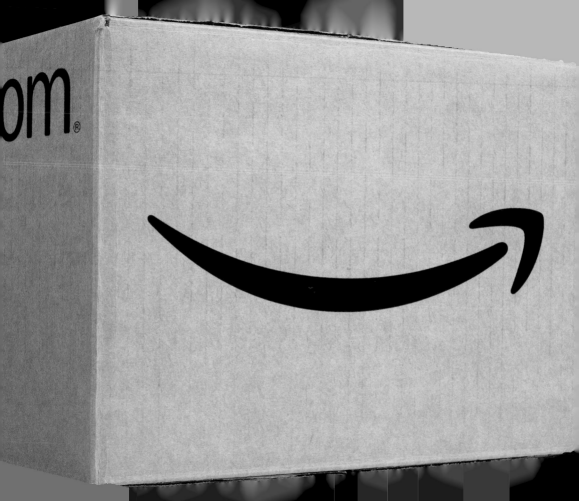

Below: Hand-crafted
Belazu's packaging was created to communicate the care with which all of the products are produced, and to identify the Mediterranean source of the foodstuffs. This is achieved through the use of the "hand-picked olive tree", the rich, warm colors, and the hand-drawn logo.

Left: The water of life
Malvern mineral water owes its name and its crisp clean taste to its filtration through the pre-Cambrian granite of the Malvern Hills, in England—hence the use of pebbles on the label. The quartz line that runs through the pebbles indicates the profile of the Malvern Hills. The intrinsic quality of the design not only imbues the product with the right messages of nature and purity, but has also helped to lift it out of the conference and boardroom, where it had found itself languishing, and made it a drink for all occasions.

Turner Duckworth's designs for drugstore Superdrug illustrate its understanding of the retailer's brand, its customers, and its positioning in relation to other UK chains like Boots. Each design has an essential freshness and what one might call "spirit", and each solution has a strong idea imbedded in the graphics. The brands exfoliating range combines natural stones arranged in the pattern of a foot with the process of walking on sand to communicate the product's action and benefits.

Superdrug's film packaging shows the mixing of primary light colors, a basic in the photographic process.
The motif, positioned on the corners of the cartons, is rotated to distinguish between 200, 400, and APS films.

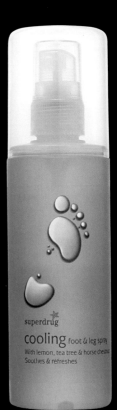

superdrug

exfoliating foot scrub

With lemon, tea tree & walnut husk
Soothes & invigorates

superdrug

relaxing foot soak

With lemon, tea tree & camomile
Soothes & softens

superdrug

cooling foot & leg spray

With lemon, tea tree & horse chestnut
Soothes & refreshes

APS

superdrug ✲
ADVANCED PHOTO SYSTEM
ideal all purpose film

superdrug ✲
COLOUR PRINT FILM
for good to fair light and flash

(25) EXP

superdrug ✲
COLOUR PRINT FILM
for action, low light or flash

200 (36) EXP

400 (24) EXP

On the can:

8.1% HIGH GRAVITY LAGER
ALC./VOL.

THE STEEL BREWING BSC COMPANY LONGVIEW, TX

STEEL® RESERVE

SLOW BREWED FOR A MINIMUM OF: 28 DAYS

1 PINT
16 FL. OZ.

EXTRA
TOASTED
BARLEY
SELECT
AGING FOR
EXTRA
GRAVITY

THE TWO ELEVEN MARK, BASED ON THE MEDIEVAL SYMBOL FOR STEEL, APPEARS ONLY ON STEEL RESERVE® HIGH GRAVITY LAGER WE USE NEARLY TWICE THE INGREDIENTS OF MANY NORMAL LAGERS & BREW FOR OVER TWICE AS LONG AS MANY QUALITY BEERS.

GOVERNMENT WARNING: (1) ACCORDING TO THE SURGEON GENERAL, WOMEN SHOULD NOT DRINK ALCOHOLIC BEVERAGES DURING PREGNANCY BECAUSE OF THE RISK

Right: Integated pull
The Canpull is an innovative kitchen gadget that levers open the lids of canned food goods that have ring pulls. The pack structure, simply hooking the Canpull product onto a cardboard cut out lid, communicates the product's purpose by bending it open to demonstrate the Canpull's functional benefits. The project is a very neat illustration of the effect that can be gained when both structural design and graphics are integrated to communicate the product proposition.

Left: Strong as steel
This beer has gone from strength (8.1% alc) to strength. Redesigned and repositioned it created a new category and went from selling a few thousand bottles and cans a year in California to now near 100% distribution in the USA. The design gives Steel Reserve an industrial-strength look and feel, to reflect the long process needed to produce it. It also positions the brand as a beer for young people who like to party not as a malt liquor for the "paper-bag crowd".

Below right: High hopes
Natural High is a range of toiletries produced using the highest level of natural ingredients. Its brand mark represents a tree and an arrow pointing upwards to endorse the Natural High proposition.

BLUEBERRY

BLACKCURRANT

CHERRY DROP

canpull

canpull

canpull

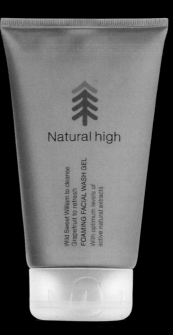

Natural high

Linden Blossom to restore
Witch Hazel to tone
INSTANT RADIANCE BALM
With optimum levels of
active natural extracts

Natural high

Witch Hazel to tone
Ginkgo Biloba to revitalise
REFRESHING TONER
With optimum levels of
active natural extracts

Natural high

Eyebright to calm
Avocado Oil to soothe
2 IN 1 CLEANSER / EYE
MAKE-UP REMOVER
With optimum levels of
active natural extracts

Natural high

Wild Sweet William to cleanse
Grapefruit to refresh
FOAMING FACIAL WASH GEL
With optimum levels of
active natural extracts

The best books

My recommendations for which books to read are based on my own reading. They are certainly not meant to be exhaustive. I have only really scratched the surface in terms of the books I could read but there's never enough time. Neither is my list meant to be prescriptive. Everyone should approach packaging design from their own perspective and read what interests and stimulates them. My own predilection is to read as widely as I can, to understand both the theory and practice of design in its entirety and specific forms.

History

I found two books interesting on packaging's history. The first, *Packaging Source Book, A Visual Guide to a Century of Packaging Design* (1991, Book Sales), is written by Robert Opie. Featuring examples from 1880 to 1989 the book illustrates the development of packaging over the years, and the influence of factors like art, fashion, and technology.

For a very American perspective on packaging's history I found Jerry Jankowski's *Shelf Space, Modern Package Design 1945-1965* (1998, Chronicle Books) very interesting and great fun. Divided into sections like Heat and Serve, Clean and Shine, Kids Stuff, and Canned Laughter, the book features work from Jankowski's own collection. The book captures the spirit of the period when America's economy was booming.

Theory

James Pilditch's 1961 book *The Silent Salesman: How to Develop Packaging that Sells* (1973, Brookfield Publishing Co.), is often cited as the book that changed people's perceptions of packaging's role in the marketing mix. It's out of print, but may turn up in a second-hand bookshop.

I found Bernd Schmitt and Alex Simonson's *Marketing Aesthetics: The Strategic Management of Brands, Identity and Image* (1997, Free Press) good on the broader subject of brand management, identity and image, and packaging's place in this subject. The book is written by two academics involved in the teaching of design at business schools and is broad in it scope. It covers subjects like Corporate and Brand Expression, Styles, Themes, and Retail Spaces and Environments.

I enjoyed reading Henry Steiner and Ken Haas's *Cross-Cultural Design: Communicating in the Global Marketplace* (1995, Thames and Hudson), because it provides an interesting perspective on how different designers handled projects outside of their own cultures. Steiner is head of Hong Kong-based Steiner and Co, and he is able to provide his own perspective on the subject of cross-cultural design. A good percentage of the work shown is not packaging but it does illustrate the need to adopt a "local mind-set".

John Simmon's book *The Invisible Grail: In Search of True Language of Brands* (2003, Texere) will be of particular interest to those people, like me, who think language is important in packaging design. I particularly enjoyed the examples he cites—like Innocent, Lush, and Guinness—as they dramatically illustrate the role language has to play.

No packaging designer can ignore the retail context of his or her work and Rasshied Din's *New Retail* (2000, Conran) is a stimulating discourse on the modern retail world from an interior designer's perspective. Full of examples from around the world the book covers a large

range of subjects as diverse as niche marketing, consumer psychology, and customer circulation patterns.

Branding

I remember when Paul Southgate's book *Total Branding by Design: Using design to Create Distinctive Brand Identities* (1994, Kogan Page) was published, as it caused considerable interest in the UK. It is a thought-provoking discussion about the greater role of packaging from a very experienced practitioner. Certainly his advocacy of packaging design, and its important role in the marketing mix, is cogently argued.

Naomi Klein's book *No Logo* (2001, Paidos Ibenica) caused quite a stir when it was published, and she has her advocates, and her critics. Personally I found her book challenging and a refreshing alternative to just accepting that brands and branding are universally good.

I read Daryl Travis's *Emotional Branding: How Successfu Brands Gain the Irrational Edge* (2000, Prima) and Jesper Kunde's *Unique Now… or Never: The Brand is the Company Driver in the New Value Economy* (2002, Prentice Hall) to gain more insights into brands, how they work, how they compete, and how they can be developed. Packaging design and branding are inextricably linked. Few designers receive a brief these days where branding is not mentioned and clients expect designers to be able to understand and differentiate them.

Stimulus

There are a considerable number of packaging books that illustrate the work of the design community, and stimulate fresh thinking.

Packaging Design (1997, RotoVision) by Conway Lloyd Morgan, *The Perfect Package— How to Add Value Through Graphic Design* (2003, Rockport) by Catherine Fishel, and *50 Trade Secrets of Great Packaging Design* (1999, Rockport) by Stafford Cliff, are good examples of books which illustrate how designers have tackled individual projects and created unique solutions.

Books like *Experimental Packaging* (2001, RotoVision), compiled and edited by Daniel Mason, and *This End Up: Original Approaches to Packaging Design* (2002, RotoVision), by Gavin Ambrose and Paul Harris, focus on projects which have "pushed" a brief, exploring new formats and approaches.

Designers

The books by designers that I have found particularly thought-provoking are *Smile in the Mind* by David Stuart, Beryl McAhlone, and Edward de Bono (1998, Phaidon), which illustrates: "Witty thinking in graphic design." *Problem Solved: A Primer for Design and Communication* by Michael Johnson (2002, Phaidon), is devoted to examining how designers solve problems for their clients across a broad spectrum of design disciplines. *Design, Form and Chaos* by Paul Rand (1993, Yale University Press), is a valuable discourse on the meaning of design. Finally, *Art Work* by David Gentleman (2002, Random House) is a fascinating insight into the thought processes and work of this interesting designer.

Glossary

The brief
The written or verbal instruction given to a designer by a client. The best briefs inform and inspire equally. They also eliminate subjectivity from the design process, enabling the design solution to be properly assessed, not subjected to personal whim.

Consumer
We are all consumers in one form or another, given that we all buy, and use a multiplicity of products. Consumer is one of those terms that people use when they don't want to say "customer" or "shopper".

Design effectiveness
Good packaging design sets out to achieve a number of commercial objectives—like increasing sales value, and volume, building brand share, reducing costs and increasing profits—and by using measurements—like sales date and materials, and production cost savings—to quantify the effectiveness of a piece of packaging design. In other words, to prove packaging design's effectiveness and success.

Differentiation
Given that consumers have so much choice these days, packaging needs to stand out to be noticed. It also needs to communicate a difference that can be readily understood and appreciated by consumers. Differentiation is one of the "holy grails" of brand owners and packaging design is one "tool" used to achieve it.

"Heart share" and "mind share"
Most people are familiar with the term "winning the people's hearts and minds" in a political context. In the world of brands "heart share" and "mind share" are short-hand terms that have been coined to describe how brands need to establish themselves in people's minds and hearts. Only by doing this will they engender loyalty and encourage repeat purchase.

Own-brand
This term is normally used to describe products sold by retailers under their own-brand name. In recent years own-brand has lost some of its negative connotations as retailers have woken up to the fact they are strong brands in their own right and have a brand equity they can exploit. Fortunately this has also resulted in retailers identifying their own values and personality traits and commissioning distinctive and unique packaging design that reflect these, rather than just creating designs that mimic proprietary brands.

Proprietary-brand
In contrast to own-brands, proprietary-brands refer to single brands owned by either multi-nationals like Procter & Gamble or smaller country-centric companies. Proprietary-brands are the mainstay of the "world of brands" we live in and each is jealously guarded by its owner.

Recyclable and recycled
It's impossible to condense the environmental issue into a few lines, but in packaging design there are two primary considerations. "Recyclable" packaging is capable of being sorted after use and its constituent parts reused in the manufacture of new packaging substrates. "Recycled" refers to packaging that contains substrates that have a measure of previously used constituents.

Retail environment

No packaging can work without a context. Retail environments exist in a host of formats; from niche shops to hypermarkets, from retail experiences like Niketown to the corner shop.

Self-selection

In the 1960s, an American, James Pilditch, coined the phrase "the silent salesman" to describe packaging's role at the "point of sale". This role is of paramount importance today. In the vast majority of cases, consumers select the product they want or need without the intervention of store staff. As a result, packaging's relevance and resonance with consumers at the point of sale is vitally important if it is to persuade consumers to buy a particular product or help them identify the one they need.

Structural packaging

This is a term used to describe packaging's three-dimensional formats in all its different guises: cartons, bottles, jars, tubs, tubes, blister and skin packs, and so on. One of the reasons the term evolved is that structural design is usually created by specialist designers schooled in different skills to graphic designers.

Surface graphics

A somewhat bald way of describing graphic elements such as typography, imagery and color, that are applied to structural packaging.

Unique selling proposition (USP) and emotional selling proposition (ESP)

In the "old days", marketers focused on finding a product's unique feature or benefit and used this to promote the product. This feature or benefit became known as a product's unique selling proposition (USP). This was fine when product choice was limited and products had a clearly differentiated USP, but increased choice, and a reduction in the discernible differences between products means it can be very difficult to identify a USP. In response, brand owners now seek a product's emotional selling proposition (ESP), a factor which offers greater scope for product differentiation. This ESP is far more concerned with engendering an emotional response to a brand.

Index

Credits

Thanks must first go to my editor Leonie Taylor at RotoVision. I am convinced there were times when she felt I would never finish the book. Despite this, she has shown great patience and provided me with encouragement when I needed it most.

Thanks to my partners, Harry Pearce and Domenic Lippa for indulging me when I said I wanted to write the book, and for patiently watching me clock up the hours.

Thanks to Richard Wilson for designing the book, for bringing my words to life, and for putting up with me changing my mind about which projects to feature— even as the deadline loomed.

Thanks to Joseph Milner for producing the artwork, and sorting out all of the images, in a ridiculously short period of time, and with stoicism.

Thanks to Abigail Silvestre, without whom this book would definitely not have been finished. Without her enthusiasm and all-round help I would not have been able to identify and track down some of the people featured in this book. Her research and tenacity has ensured the book contains examples of work from around the world.

Thanks to all the design companies for allowing me to feature their work; to Benefit, Charles Worthington, Clarks, Escada, Garnier, Jean Paul Gaultier, Natural Products Ltd, Umberto Giannini, and Zirh for allowing us to include their packaging, and to Waitrose for allowing me to photograph its Kingston store. Thanks also to Shiseido's Corporate Art Museum for supplying the transparencies of its work. My thanks to the Lippa family for the use of their collection of cigarette packs.

Thanks to Quentin Newark at Atelier Works who wrote the first book in the series *What is Graphic Design?*. His book has sat by my desk throughout the writing of this one, and acted as both an inspiration and a spur.

Last, and definitely not least, much love and the hugest thanks to my wife Jo, and my sons Rory and Jake, for putting up with a distracted, and at times absent, husband and father for several months.